Cameras

MACCHINE FOTOGRAFICHE

Prince R. de Croÿ-Roeulx

CHRONICLE BOOKS

SAN FRANCISCO

First published in the United States of America by Chronicle Books in 1997.
Copyright © 1993 by BE-MA Editrice.

Printed in Hong Kong.

Library of Congress Cataloging-in-Publication Data:
Cröy-Roeulx, R. de, Prince.
 [Macchine fotografiche. English & Italian]
 Cameras = macchine fotografiche / Prince R. de Cröy-Roeulx
 p. cm — (Bella cosa library)
 ISBN 0-8118-1471-8 (pb)
 1. Cameras—History—19th century. 2. Cameras—History—20th century.
 3. Cameras—History—19th century—Pictorial works. 4. Cameras—History—20th
 century—Pictorial works. I. Title II. Series.
 TR250.C7613 1996
 771.31—dc20 96-12491
 CIP

Translation: Joe McClinton
Photography: Tony Fedeli
Series design: Dana Shields, CKS Partners, Inc.
Design/Production: Robin Whiteside

Distributed in Canada by Raincoast Books
8680 Cambie Street
Vancouver, B.C. V6P 6M9

10 9 8 7 6 5 4 3 2 1

Chronicle Books
85 Second Street
San Francisco, California 94105

Web Site: www.chronbooks.com

Cameras

*T*he public welcomed the arrival of the first cameras on the market with extraordinary enthusiasm; these instruments seemed able to record miraculously for posterity what until then had lasted only for the duration of a glance or a smile. Before photography, only painting, drawing, or sculpture had been able to lend their subjects a semblance of immortality.

The Age of Photography began in 1822, permitting everyone to preserve memories and record their most precious moments. The following pages take us on a voyage across time with a range of cameras that are splendid, unique, and even witty.

Ensign Popular Reflex

1917 - GREAT BRITAIN

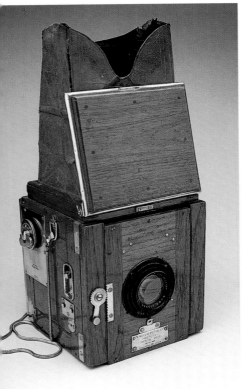

A tropical reflex. A professional photographers' camera intended for use in hot, humid countries, particularly the colonies.

Ensign Popular Reflex - 1917 - Gran Bretagna

Reflex tropicale. Apparecchio per servizi fotografici destinato in principio ad essere utilizzato nei paesi molto caldi e umidi, in particolar modo nelle colonie.

A novel camera able to make fifteen 3 x 3 cm exposures on a single plate measuring 13 x 18 cm. The shutter on this camera is an older model, made in Paris by the optician Derogy.

Simon Wing - 1901 - U.S.A.

Fotocamera originale in grado di fare 15 riprese di formato 3 x 3 cm su una sola lastra di 13 x 18 cm. L'otturatore posto su questo apparecchio è un modello più antico fabbricato a Parigi dall'ottico Derogy. ➢

Simon Wing

1901 - U.S.A.

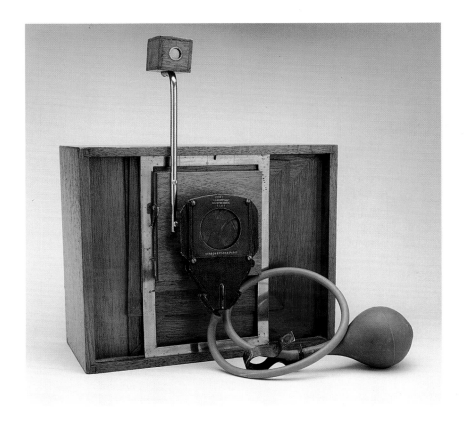

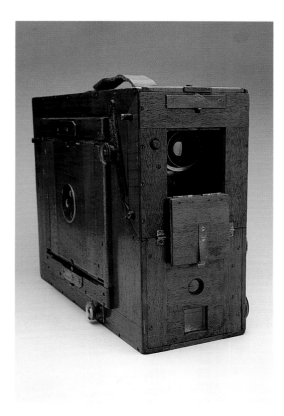

Armand le Docte

1890 - BELGIUM

A large and rare mahogany "detective." A limited and highly prized edition from Belgium. The lens system is English.

Armand Le Docte - 1890 - Belgio

Grande e raro "Détective" in mogano, di pregiata e limitata fabbricazione belga. Obiettivo inglese.

Camera from the Atelier of Marco Mendoza

1885 - FRANCE

A camera for use with wet collodion plates. The sliding back allowed the photographer to make three exposures in succession.

Fotocamera d'Atelier Marco Mendoza - 1885 - Francia

Apparecchio progettato per l'utilizzo di lastre al collodio umido. Il dorso scorrevole permetteva di fare 3 riprese consecutive.

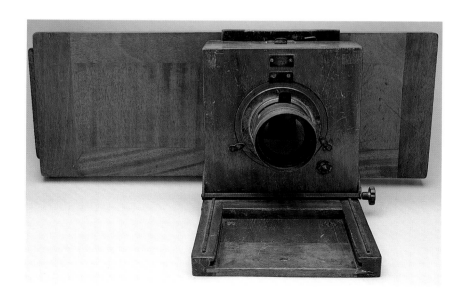

Dr. Krügener's Delta Camera

1893 - GERMANY

A high-quality camera equipped with twelve plates that were changed mechanically.

Camera Delta del Dr. Krügener - 1893 - Germania

Apparecchio di alta qualità munito di 12 lastre a ricambio automatico.

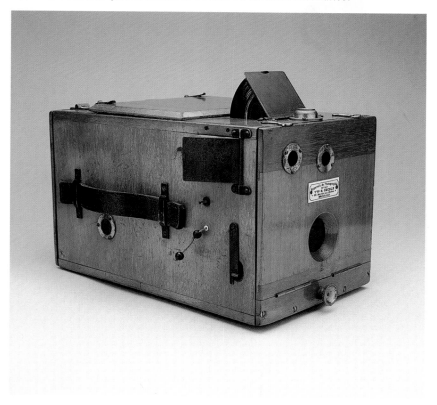

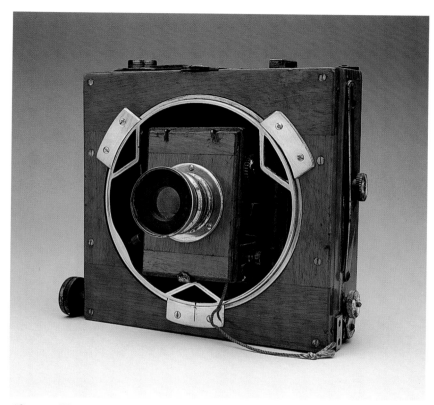

Beck Folding Camera

1895 - GREAT BRITAIN

This camera has a special leather attachment system for the base and is made of finest mahogany and leather.

Camera pieghevole Beck - 1895 - Gran Bretagna
Sistema speciale di fissaggio della base in cuoio.

Stereo Traveling Camera - Wratten & Wainwright

1885 - GREAT BRITAIN

Stereoscopic photography—using either two lenses or a single lens mounted on a sliding plate—was very popular from the mid-nineteenth century on.

Camera da viaggio stereo - Wratten & Wainwright - 1885 - Gran Bretagna

La fotografia stereoscopica effectuata sia con apparecchi a due obiettivi, sia con un solo obiettivo fissato su una piastra scorrevole, connobbe una grande fortuna dalla metà del 19° secolo in poi.

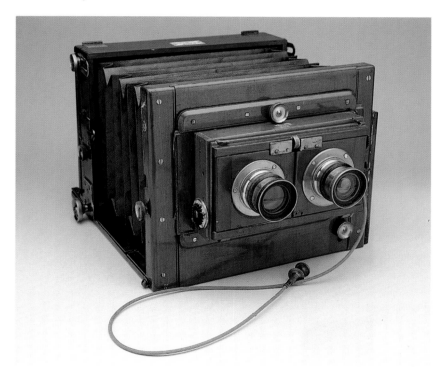

G. Hare Camera

A stereoscopic system with a sliding lens. The wooden shutter is gravity-operated—simple, but effective and reliable.

Camera G. Hare - 1880 circa - Gran Bretagna

Sistema stereoscopico a scorrimento. Otturatore a gravità in legno, semplice, ma efficace e affidabile.

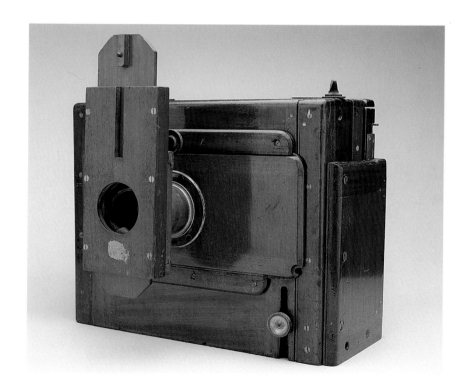

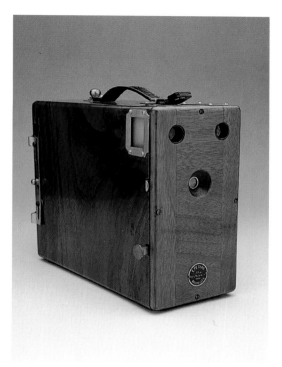

E. Peeters, Brussels

1895 - BELGIUM

A small, rare "detective" made entirely of mahogany.

E. Peeters Bruxelles - 1895 - Belgio

Piccolo e raro "Detective," interamente in mogano.

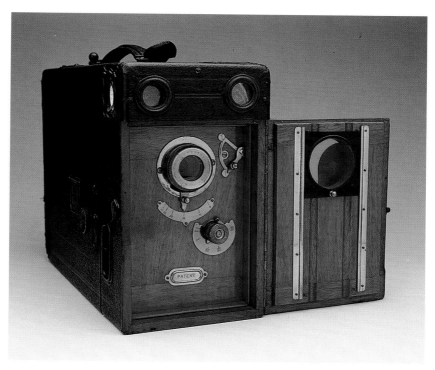

Houghton's Klito No. 3

1907 - GREAT BRITAIN

A good-quality English "detective." Shut, the camera is not remarkable in the least; but once opened up, it is resplendent with lustrous mahogany and shiny brass.

Houghton's Klito N° 3 - 1907 - Gran Bretagna

"Detective" inglese di buono qualità. Chiuso, questo apparecchio non è per nulla attraente, ma, una volta aperto, risplende in tutta la lucentezza del mogano e nella brillantezza dell'ottone.

Ernemann Tropical
1904 - GERMANY

This handsome press camera has a "clap" type extending body. It was one of the first cameras to be produced for tropical use.

Ernemann Tropical - 1904 - Germania

Questo bell'apparecchio da reportage possiede il corpo estensibile, del tipo "clap" (a scatto). E' uno dei primi apparecchi ad essere stato costruito per un uso tropicale.

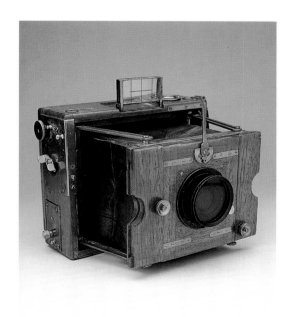

The Stereoscopic Company Ltd.

1890 - GREAT BRITAIN

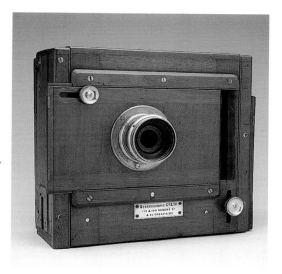

An attractive stereo camera with a sliding plate system. This system produced results as good as cameras with two lenses, provided the two exposures were made in quick succession. It worked best for landscape photography.

The Stereoscopic Company Ltd - 1890 - Gran Bretagna

Bella fotocamera stereo con sistema a scorrimento di piastra. Questo sistema eguagliava, nei risultati, il sistema a due obiettivi, a condizione però che le due riprese venissero effettuate in rapida sequenza consecutiva. Utilizzo ottimale per i paesaggi.

Schrambach Nux, Paris

1900 - FRANCE

A walnut studio camera. Walnut was the wood most commonly used in France, while the English preferred mahogany.

Schrambach Nux Parigi - 1900 - Francia

Fotocamera da studio in noce. Il legno più frequentemente utilizzato in Francia era il noce, mentre in Inghilterra si prefriva il mogano.

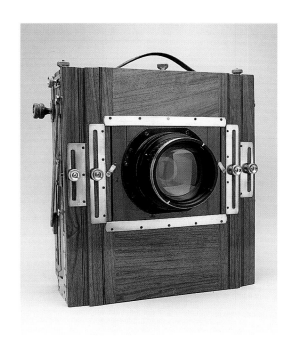

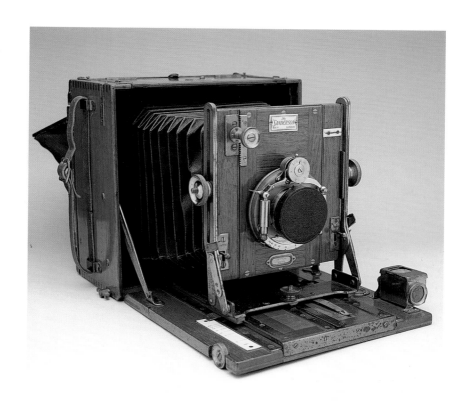

Sanderson "Tropical Model"

1900 - GREAT BRITAIN

A large folding camera of very fine quality. It was often used by explorers, travelers, and hunters, especially in Africa.

Sanderson "Tropical Model" - 1900 - Gran Bretagna

Grande apparecchio pieghevole a ribalta di pregiata qualità. Era spesso utilizzato dai grandi esploratori, viaggiatori e cacciatori, soprattutto in Africa.

Watson Alpha No. 3

1892 - GREAT BRITAIN

*I*n its day, this very handsome camera was the best England made. The mahogany was top quality, as were the optical system and every other accessory. The leather of the red bellows is simply superb. The squared angles on this bellows are typical of cameras made before 1900.

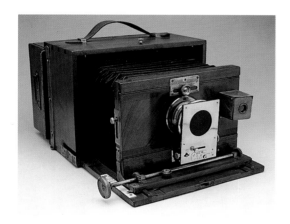

Watson Alpha N° 3 - 1892 - Gran Bretagna
Questo bellissimo apparecchio era ciò che di meglio si fabbricava al tempo in Inghilterra. Il mogano era della miglior qualità, come pure l'ottica e tutti gli altri accessori; il soffietto rosso è fabbricato in un cuoio stupendo. Gli angoli squadrati di questo soffietto sono tipici di una fabbricazione anteriore al 1900.

Léon Rovier

1892 - BELGIUM

A large, rare folding camera with a baseboard, made in Belgium. French *Le Mignon* leaf shutter.

Léon Rovier - 1892 - Belgio
Grande e raro apparecchio pieghevole a ribalta di fabbricazione belga. Otturatore francese e lamelle "Le Mignon." ➤

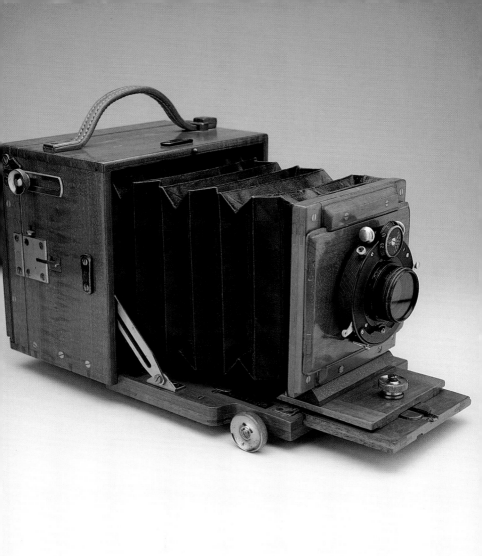

L. Gaumont & Cie
1912 - FRANCE

A luxurious camera for travel or the studio. The whole thing is exceptional for the technology it used and the excellent quality of its manufacture.

L. Gaumont & Cie - 1912 - Francia

Lussuosa macchina da viaggio e da studio. L'insieme è eccezionale per la tecnica utilizzata e la pregevole qualità della fabbricazione.

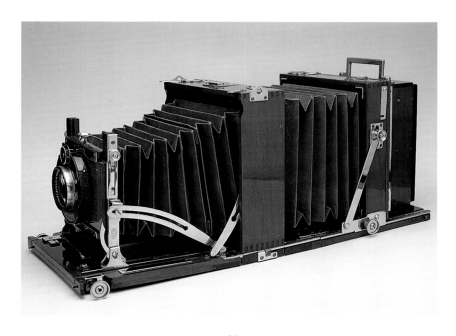

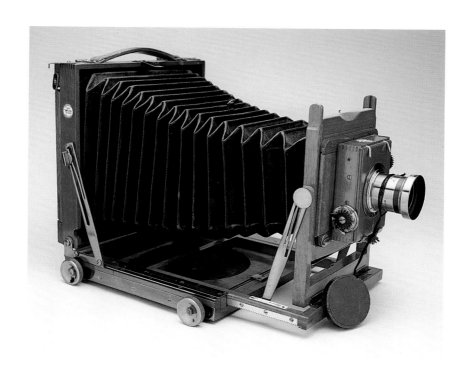

Thornton Pickard "Imperial Triple Extension"

1 9 0 8 - Great Britain

This magnificent travel camera was a great success, widely used by tourists and travelers from all over Europe. Thornton Pickard made very fine focal-plane shutters favored by many photographers.

Thornton Pickard "Imperial Triple Extension" - 1908 - Gran Bretagna

Questa lussuosa fotocamera da viaggio conobbe un grande successo e fu largmente utilizzata da turisti e viaggiatori di tutta l'Europa. Thornton Pickard fabbricava bellissimi otturatori a tendina utilizzati da un gran numero di fotografi.

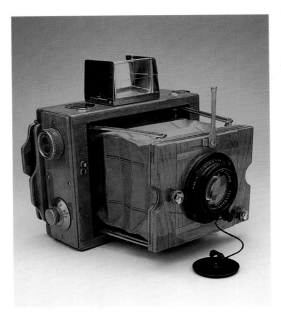

Ernemann Tropical
1925 - GERMANY

A luxurious folding camera with "clap" struts. This was the most advanced version of this type of professional photographers' camera.

Ernemann Tropical - 1925 - Germania

Lussuoso apparecchio pieghevole con estensori "clap" (a scatto). E'la versione più evoluta in questo tipo d'apparecchi per servizi fotografici.

Pony Premo No. 5

1 9 0 0 - U . S . A .

The most highly prized and popular American cameras were made by the optical firm Rochester, founded in 1883 and later absorbed by George Eastman—in other words, Kodak.

Pony Premo N° 5 - 1900 - U.S.A.

Gli apparecchi americani più pregiati e popolari erano fabbricati dalla compagnia ottica Rochester, fondata nel 1883 e assorbita più tardi da George Eastman, ovvero dalla Kodak.

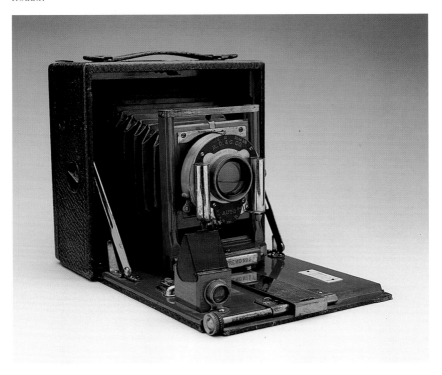

Folding Pony Premo No. 4

1906 - U.S.A.

\mathcal{A} fine American instrument from the early years of the century. This camera, more recent than the one on the preceding page, was enhanced with an excellent "volute" shutter made in Rochester, New York, by Bausch & Lomb. More recent than the camera itself, this shutter remained in production until 1935.

Pony Premo pieghevole N° 4 - 1906 - U.S.A.

Bella produzione americana risalente agli inizi del secolo. Questo apparecchio, più recente del precedente, è equipaggiato di un eccellente otturatore del tipo "volute" fabbricato a Rochester, New York, dagli ottici Bausch & Lomb. Questo otturatore, posteriore all'apparecchio, rimase in produzione sino al 1935.

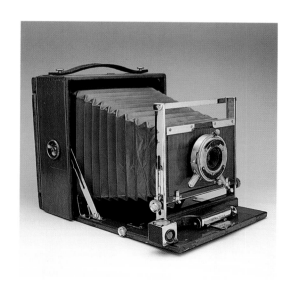

Thornton Pickard Ruby

1890 -
GREAT BRITAIN

A fine camera for mono and
stereo photography. This is a
large instrument for 13 x 18
cm plates.

Thornton Pickard Ruby -
1890 - Gran Bretagna

Bella camera per riprese mono
e stereo. Si tratta di un
grande formato per lastre di
13 x 18 cm.

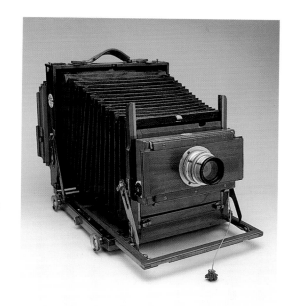

Large-Format Folding Gaumont

1910 - FRANCE

French camera, English shutter, German lens system. In this era Gaumont produced cameras of only the highest quality.

Folding Gaumont di grande formato - 1910 - Francia

Apparecchio francese, otturatore inglese, obiettivo tedesco. A quell'epoca Gaumont produceva solo apparecchi della miglior qualità.

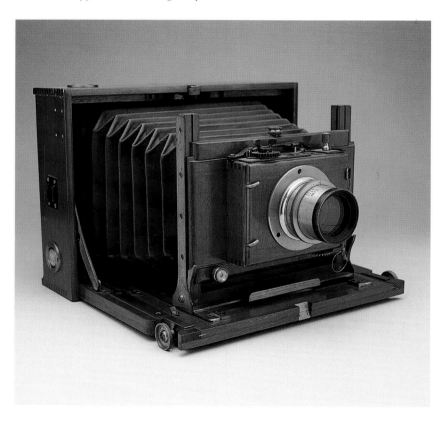

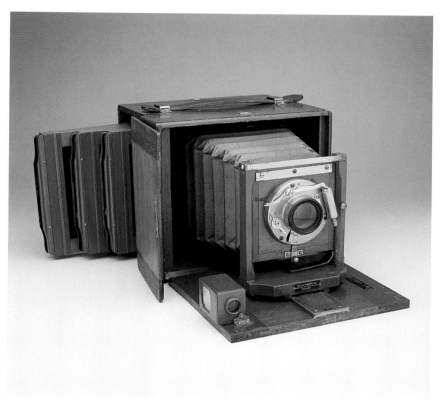

Folding Mahogany "Rodolphe"

1903 - BELGIUM

Of English manufacture but intended for export. The back held a number of mahogany plates.

Pieghevole "Rodolphe" in mogano - 1903 - Belgio

Fabbricazione inglese destinata all'esportazione. Il dorso conteneva numerose piastre in mogano.

Watson Mono/Stereo Travel Camera

1890 - GREAT BRITAIN

This camera is equipped with a side support and a squared-off bellows with which the photographer could take either mono or stereo shots by swapping lens systems.

Camera da viaggio mono/stereo Watson - 1890 - Gran Bretagna

Questo apparecchio è munito di un supporto laterale e di un soffietto squadrato che permetteva di fare riprese mono o stereo cambiando d'obiettivo.

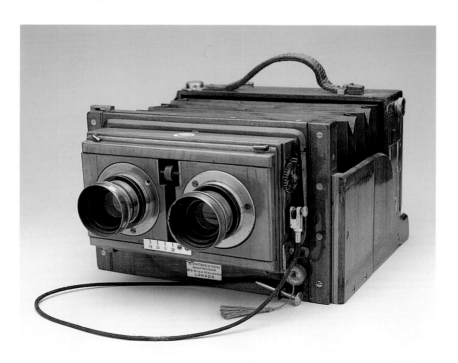

R. & J. Beck, London

1880 - GREAT BRITAIN

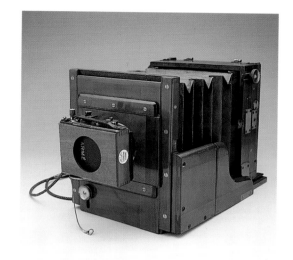

A handsome camera with a side support, made of mahogany. The shutter is a classic Thornton Pickard, a little more recent than the camera itself (ca. 1890). It could handle speeds from 1/15th to 1/90th of a second.

R. & J. Beck, London - 1880 - Gran Bretagna

Bell'apparecchio a supporto laterale in mogano.

L'otturatore è un Thornton Pickard classico un po' più recente dell'apparecchio (1890 circa). Esso permetteva tempi di posa compresi fra 1/15 ad 1/90 di secondo.

Contessa Nettel Tropical

1920 - GERMANY

A luxurious press camera. A camera without equal for construction and finish.

Contessa Nettel Tropical - 1920 - Germania
Lussuoso apparecchio per reportages. Nella costruzione e nella finitura questo apparecchio raggiunse un grado di perfezione mai eguagliato.

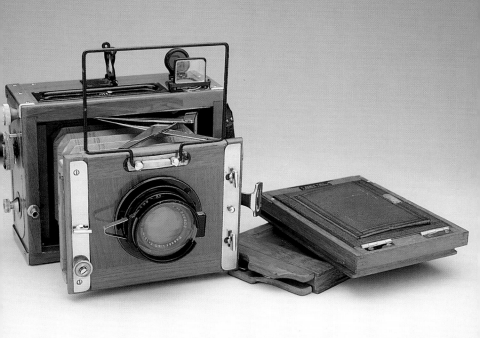

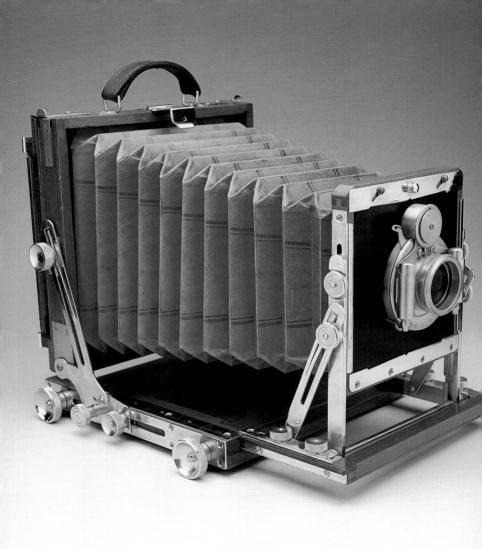

Travel Camera
CIRCA 1960 - JAPAN

A high-quality modern copy of a travelers' camera from before World War I. This model is made of teak, and all the metal parts are gold-plated.

Fotocamera da viaggio - 1960 circa - Giappone

Pregevole copia di una fotocamera da viaggio risalente a prima dell guerra del 1914–18. Questo modello è in teak e tutte le parti metalliche sono placcate d'oro.

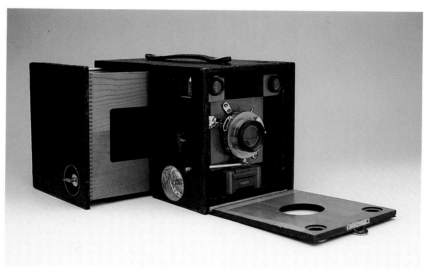

Kodak Bull's Eye Special
1904 - U.S.A.

A superbly built instrument to be used with the "new" type-123 film. It took pictures measuring 4 x 5 inches.

Kodak Bull's Eye Special - 1904 - U.S.A.

Apparecchio superbamente costruito, destinato alla "nuova" pellicola 123. Permetteva di fare riprese di 4 x 5 pollici.

ESPI (Otto Spitzer, Berlin)

1910 - GERMANY

\mathcal{A} simple, austere folding model for 13 x 18 cm plates.

ESPI (Otto Spitzer, Berlin) - 1910 - Germania
Apparecchio pieghevole semplice e austero per lastre di formato 13 x 18 cm.

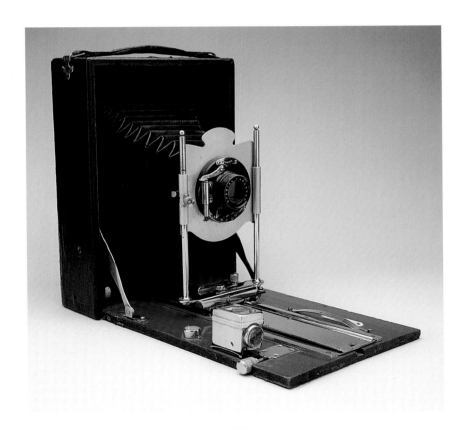

1 A Speed Kodak

1 9 0 9 - U . S . A .

*T*his model was one of the first to achieve a shutter speed of 1/1000th of a second. The viewfinder let the photographer use the camera at either eye level or waist level, thanks to a small tilting mirror.

1 A Speed Kodak - 1909 - U.S.A.

Questo apparecchio è stato uno dei primi a possedere un otturatore che andava fino ad 1/1000 di secondo. Il mirino permetteva l'utilizzazione sia all'altezza dell'occhio sia all'altezza della cintola grazie ad uno specchietto inclinabile.

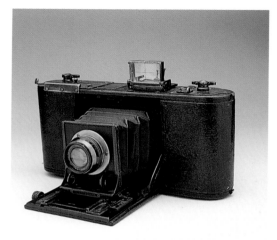

Dr. R. Krügener

1898 - GERMANY

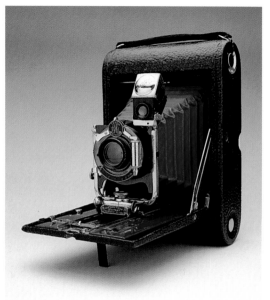

Doctor Rudolf Krügener, in Frankfurt, was one of the first German industrialists to engage in camera construction. This simple instrument was a basic model intended for the general public.

Dr. R. Krügener - 1898 - Germania

Il dottor Rudolf Krügener fu uno dei primi industriali tedeschi a lanciarsi nella costruzione d'apparecchi fotografici a Francoforte. Questo semplice apparecchio era un modello di base destinato al grande pubblico. ➢

Kodak Folding Pocket No. 4 A

1906 - U.S.A.

A camera typical of a wide, varied product line from the Eastman Kodak Company before World War I. Though called a "pocket" model, this camera took photos on film in 10 x 12 cm format.

Kodak Folding Pocket N° 4 A - 1906 - U.S.A. (pieghevole-tascabile)

Apparecchio tipico di una vasta e varia produzione della Eastman Kodak Company, risalente a prima della guerra del 1914. Nonostante la qualifica di "tascabile", questo apparecchio produceva fotografie su una pellicola di formato 10 x 12 cm.

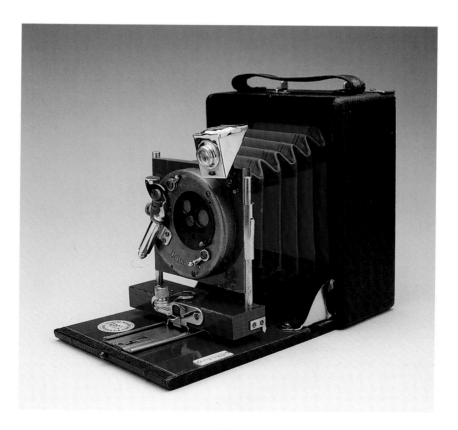

L'universelle (Le Rêve)

1908 - FRANCE

A high-quality camera produced under license at St. Etienne in France. It could be used with either plates or film, thanks to interchangeable back panels. The original model was the Ernemann "Zweifach-Kamera."

L'universale (Il sogno) - 1908 - Francia

Apparecchio di qualità fabbricato sotto licenza a St. Etienne in Francia. Poteva essere utilizzato sia con lastre sia con pellicole grazie a dorsi inter-cambiabili. L'apparecchio originale era l'Ernemann "Zweifach kamera."

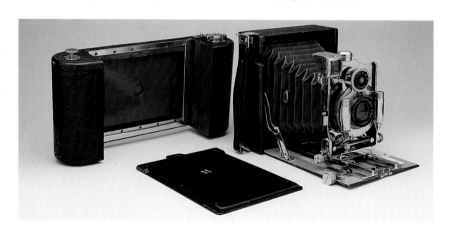

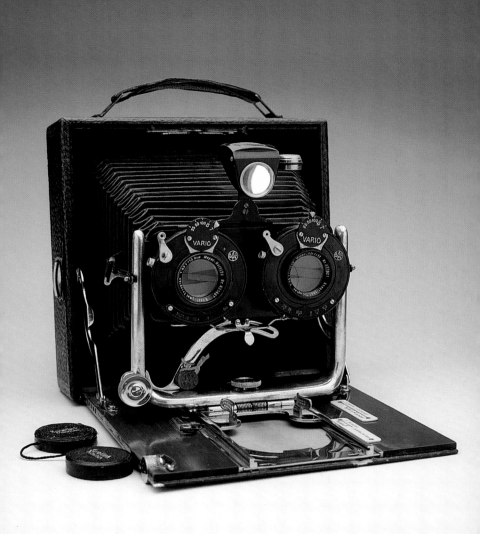

Kodak No. 4 Cartridge

1 8 9 7 - U . S . A .

A good-quality camera with mirror viewfinders built into the camera body, to the left and right of the baseboard.

Kodak N° 4 Cartridge - 1897 - U.S.A.
Apparecchio di qualità i cui mirini a specchio erano incorporati nel corpo della fotocamera, a destra e a sinistra della ribalta. ➤

Emil Wünsche

1 9 0 6 - GERMANY

A handsome stereo camera in square format, 14 x 14 cm. Emil Wünsche was known first and foremost as an excellent shutter maker. In 1909 he went into partnership with Hüttig, Krügener, and Palmos-Karl Zeiss to form the celebrated company ICA. (Preceding page)

Emil Wünsche - 1906 - Germania
Bell'apparecchio stereo dal formato squadrato di 14 x 14 cm. Emil Wünsche fu in primo luogo un eccellente costruttore di otturatori. Nel 1909 si associò con Hüttig, Krügener e Palmos-Karl Zeiss per costituire la celebre società ICA.
◄

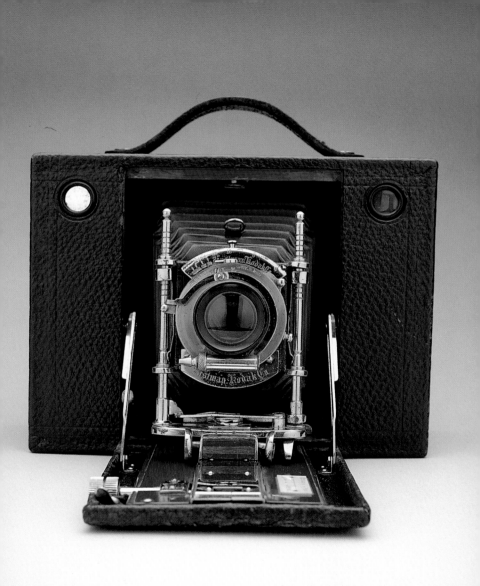

Kodak Screen Focus No. 4

1904 - U.S.A.

An unusual camera with a back that rotated up so the picture could be focused on the ground glass. It could take 4 x 5 inch shots on large-format type-123 film specially created for it.

Kodak Screen Focus N° 4 - 1904 - U.S.A.

Originale apparecchio il cui dorso ruotava verso l'alto per permettere la messa a fuoco sul vetro smerigliato. Era in grado di fare riprese di 4 x 5 pollici su una grande pellicola n. 123 per esso appositamente creata.

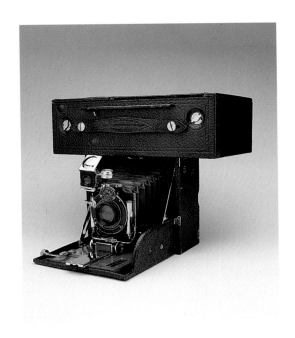

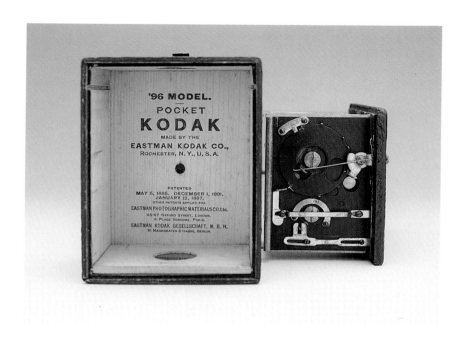

Pocket Kodak, '96 Model

1 8 9 6 - U . S . A .

A tiny, very carefully made box camera. It could make twelve 5 x 4 cm exposures. This model measures only 10 x 8 x 6 cm and weighs only 180 grams.

Pocket Kodak '96 Model - 1896 - U.S.A.

Piccolissimo apparecchio a cassetta fabbricato con molta cura. Faceva 12 riprese di 5 x 4 cm. Questo modello misurava solo 10 x 8 x 6 cm e non pesava che 180 gr.

Royal Detectif or Ultime Spécial

1893 - BELGIUM

*A*n unusual camera with a removable shutter and a leather compartment for changing the plates. Apart from the shutter, this model is absolutely typical of a camera style widely used during the last third of the nineteenth century, the forerunner of the box camera.

Le Royal Detectif o Ultime Spécial - 1893 - Belgio

Apparecchio originale con otturatore asportabile e cambiamento delle lastre in uno scomparto di cuoio. Ad eccezione del suo otturatore, questo modello è assolutamente caratteristico di un genere d'apparecchio fotografico molto diffuso dall'ultimo terzo del 19° secolo e da esso derivò, un po' più tardi, l'apparecchio "box."

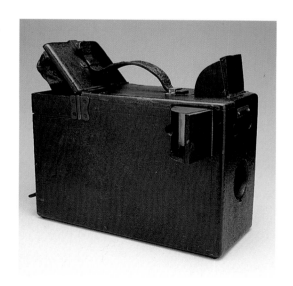

Folding Pocket Kodak No. 1 A

1903 - U.S.A.

This folding camera with struts had fixed coupled viewfinders—unlike most similar models from Kodak, which used a single viewfinder with a tilting mirror.

Folding Pocket Kodak N° 1 A - 1903 - U.S.A.

Questo apparecchio pieghevole a estensori era dotato di mirini accoppiati fissi, contrariamente alla maggior parte di apparecchi simili della Kodak, i quali utilizzavano un solo mirino a specchio basculante.

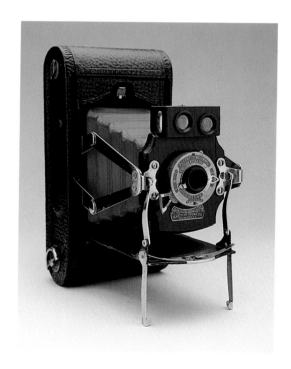

Kodak Panoram No. 4

1 9 0 3 - U . S . A .

This camera has a lens that can swivel through an angle of 142 degrees. It could make four exposures, measuring 8.8 x 30.4 cm, on large roll film.

Panoram Kodak N° 4 - 1903 - U.S.A.

Questo apparecchio è dotato di un obiettivo girevole che descrive un angolo di 142°. Permetteva di fare 4 riprese di 8,8 x 30,4 cm su una pellicola a grandi bobine.

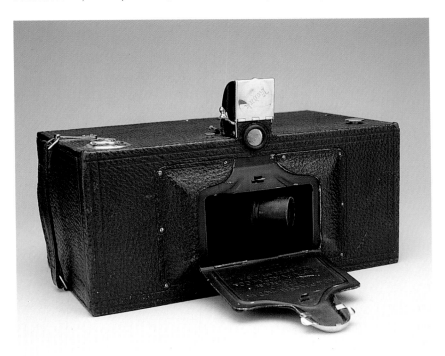

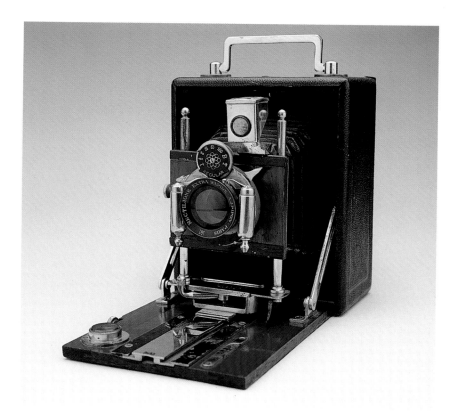

A. J. Pipon - Paris

1899 - FRANCE

This camera was entirely built by the Parisian optician A. Pipon, one of the very few who produced both lenses and shutters himself.

A. J. Pipon - Paris - 1899 - Francia

Questo apparecchio fu interamente costruito dall'ottico parigino A. Pipon, il quale, fatto molto raro, produceva da sè obiettiva e otturatori.

ICA Reflex

1912 - GERMANY

A camera in 9 x 12 cm format for plates, used by many professionals before 1914. The lens is held in place by a mechanical iris system, a kind of diaphragm, and can be changed very quickly.

ICA Reflex - 1912 - Germania

Apparecchio di formato 9 x 12 cm per lastre utilizzato da molti professionisti prima del 1914. L'obiettivo è tenuto a posto da un sistema meccanico a iride, una sorta di diaframma, e può essere quindi cambiato molto rapidamente.

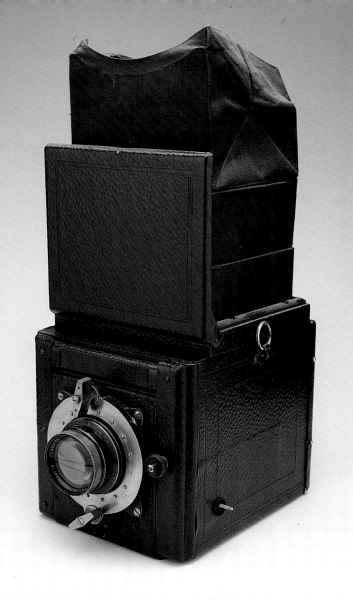

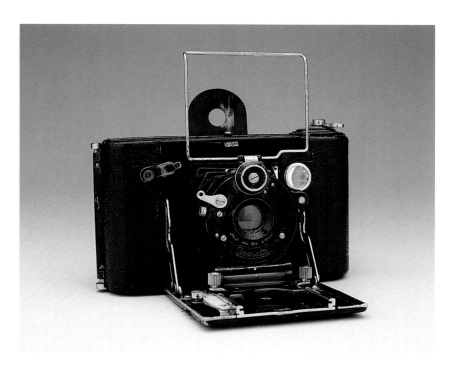

ICA "Icarette"

1914 - GERMANY

A lightweight, compact model that took shots measuring 6 x 6 cm on roll film. It was widely used in World War I by German soldiers on reportage or reconnaissance missions at the front.

ICA "Icarette" - 1914 - Germania

Apparecchio compatto e leggero faceva riprese di 6 x 6 cm su pellicola a rullo. Venne largamente utilizzato, durante la guerra del 1914–18, dai soldati tedeschi incaricati di effettuare missioni di reportage o di ricognizione sul fronte.

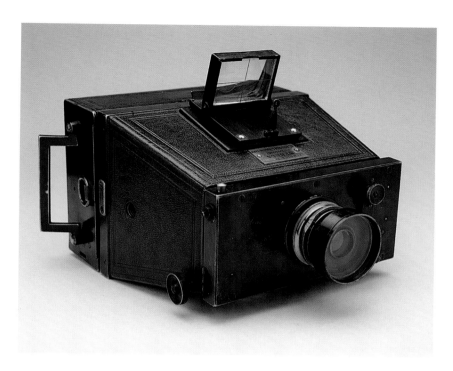

Stella

1899 - FRANCE

A camera of the "jumelle" (binocular) type, made with great attention to detail by the Parisian optician H. Roussel. Format: 9 x 12 cm. A seven-speed guillotine shutter.

Stella - 1899 - Francia

Apparecchio di tipo "jumelle" ("binoculare") fabbricato con molta cura dall'ottico parigino H. Roussel. Formato: 9 x 12 cm. Otturatore a sette velocità a ghigliottina.

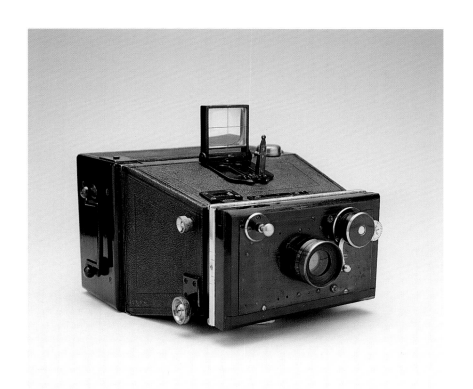

H. Mackenstein

1889 - FRANCE

A fine binocular-type camera fitted with a five-speed shutter from the same maker.

H. Mackenstein - 1889 - Francia

Apparecchio di tipo "jumelle" (binoculare) di bella qualità, equipaggiato di un ottura-tore a cinque velocità della medesima marca.

Mackenstein Stereo

An improved binocular-type camera. It could make mono or stereo exposures on 18 x 7 cm plates.

Mackenstein Stereo - 1895 - Francia

Apparecchio perfezionato di tipo "jumelle" (binoculare); faceva riprese mono o stereo su lastre di formato 18 x 7 cm.

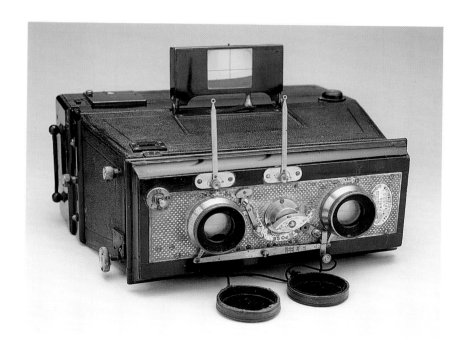

F. Girard & Cie Folding Camera

CIRCA 1900 - FRANCE

A camera for large roll film. The manufacturer made attractive cameras of a design unusual for the day.

Folding F. Girard & Cie - 1900 circa - Francia

Apparecchio per pellicole su grandi bobine. Il fabbricante realizzava apparecchi di bel design e di concezione originale rispetto alle forme dell'epoca.

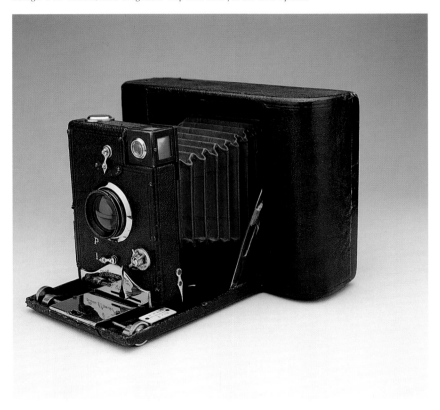

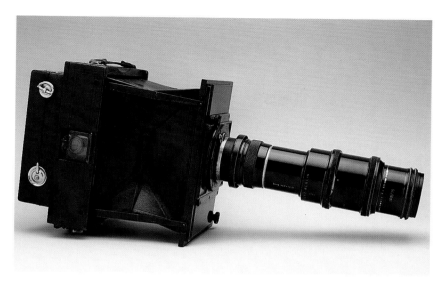

Goertz "Ango"

1906 - GERMANY

This "clap" type folding camera still has a cardboard stamp from the Paris *douane* (customs office). The 175-mm telephoto lens was a very rare piece for the time.

Goertz "Ango" - 1906 - Germania

Questo apparecchio pieghevole di tipo "clap" (a scatto), porta ancora il timbro in cartone della dogana di Parigi. Il teleobiettivo di 175 mm era all'epoca un pezzo molto raro.

Newman & Guardia Baby Sibyl

1910 - GREAT BRITAIN

An unusual and elegant camera for 4.5 x 6 cm plates. The body has a technologically advanced shutter. The detachable viewfinder and other accessories were the most sophisticated of their day.

Newman & Guardia Baby Sibyl - 1910 - Gran Bretagna

Apparecchio originale e raffinato per lastre di 4,5 x 6 cm. Il corpo contiene un otturatore tecnologicamente avanzato; il mirino staccabile e gli altri accessori sono quanto di più sofisticato l'epoca permettesse.

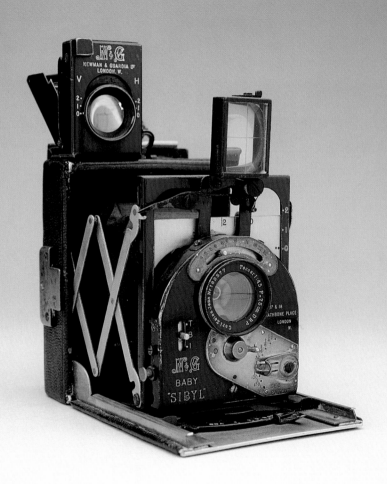

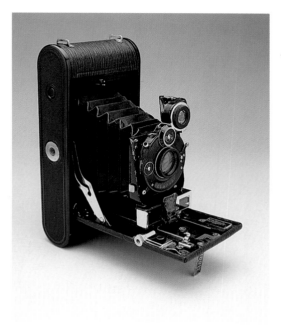

Kodak 1 A Autographic Special
1918 - U.S.A.

This was one of the first cameras to be equipped with a coupled rangefinder in front.

Kodak 1 A Autographic Special - 1918 - U.S.A.
Questo apparecchio è uno dei primi ad essere dotato di un telemetro accoppiato situato davanti, sul battente.

Gaumont "Bloc Notes Stereo"
1905 - FRANCE

An admirable technical accomplishment. The shutter was set up to make the front plate, with the lenses, travel back and forth.

Gaumont "Bloc Notes Stereo" - 1905 - Francia
Bella realizzazione tecnica. L'otturatore era attrezzato in moda tale da fare scorrere, in un senso e nell'altro, la piastra frontale che portava gli obiettivi. ➤

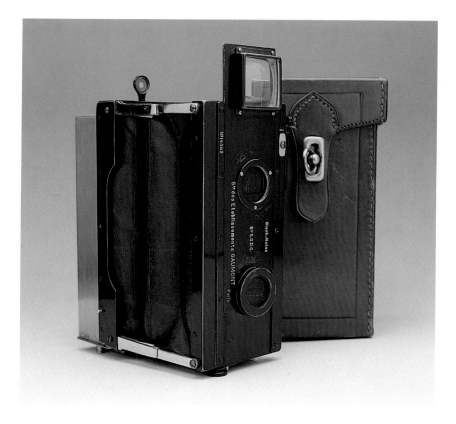

Ensign Cupid

1922 - GREAT BRITAIN

To make a change from the usual box shape, the English manufacturer Houghton bought a patent that had been taken out by A. J. Dennis and V. N. Edwards in 1922. The result was this curious, and totally unsuccessful, "Cupid."

Ensign Cupid - 1922 - Gran Bretagna

Per cambiare la forma usuale delle cassette ("box"), il fabbricante inglese Houghton comprò un brevetto concesso nel 1922 a A. J. Dennis e V. N. Edwards. Il risultato fu questo curioso "Cupido," che non ottenne alcun successo.

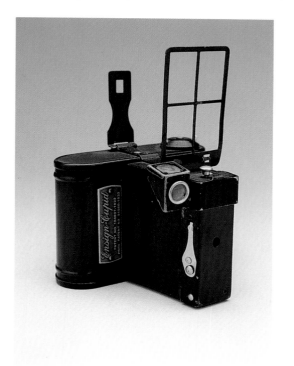

Ansco Memo (Anthony & Scovill)

1 9 2 7 - U . S . A .

This camera could make fifty exposures in a moving-picture format. The film was very rapidly transported by a claw mechanism at the back of the camera body.

Ansco Memo (Anthony & Scovill) - 1927 - U.S.A.
Questo apparecchio faceva 50 riprese formato cinema. La pellicola vineva trasportata, molto rapidamente, da un meccanismo a griffe situato sul retro del corpo della fotocamera.

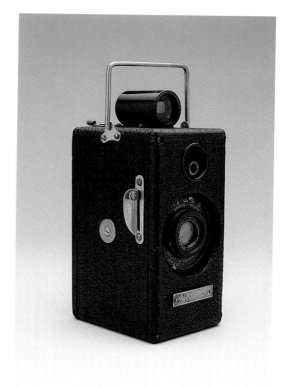

A. Debrie "Le Sept"

1924 - FRANCE

A rare and unusual camera that could make 250 continuous exposures, thanks to a motor with a clockwork movement. It could also be used as a movie camera.

A. Debrie "Le Sept" - 1924 - Francia

Apparecchio raro e originale permetteva di fare 250 riprese continue grazie ad un motore con movimento ad orologeria. Poteva servire anche da apparecchio per cinema.

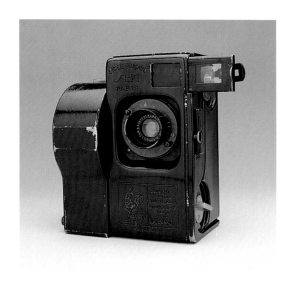

Guerin "Le Furet"

1923 - FRANCE

A very compact camera that could make 24 x 36 mm exposures on a standard film housed in special cassettes.

Guerin "Le Furet" - 1923 - Francia

Apparecchio molto compatto faceva riprese di 24 x 36 mm su pellicola standard ma in cassette speciali.

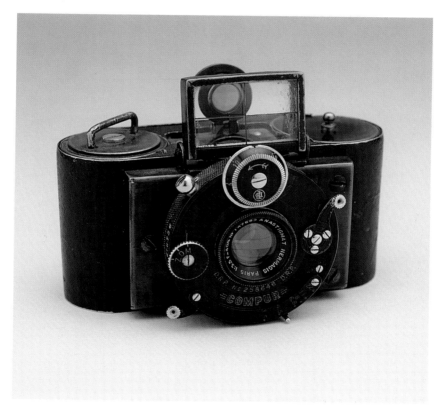

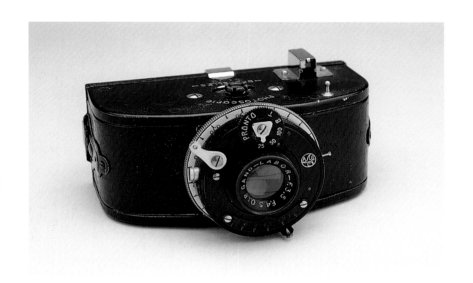

Le Photoscopic

1930 - BELGIUM

An odd compact camera that made fifty 24 x 24 mm exposures on film in special cassettes. It is one of the rare Belgian models from this period.

Le Photoscopic - 1930 - Belgio

Curioso apparecchio compact faceva 50 riprese 24 x 24 mm su una pellicola contenuta in cassette speciali. E' una delle rare fabbricazioni belga di questo periodo.

Rolleiflex I

1930 - GERMANY

After this first camera, Franke and Heidecke of Braunschweig continued for years to produce much-admired cameras that were used by both professionals and skilled amateurs.

Rolleiflex I - 1930 - Germania

Dopo questo primo apparecchio, la ditta Franke & Heidecke di Braunschweig costruì per molti anni apparecchi prestigiosi utilizzati sia dai professionalisti sia dagli amatori competenti.

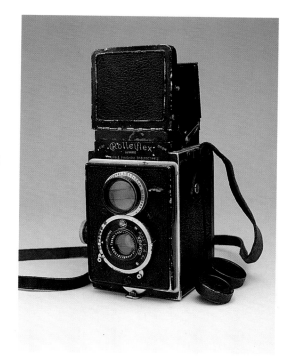

Welta Perfecta

1934 - GERMANY

A highly prized twin-lens reflex with a highly original design: When the camera is opened the entire front of the camera comes away from the back. Only one other camera, of another brand, the Zeca-flex, used a similar configuration.

Welta Perfecta - 1934 - Germania

Pregiato reflex a due obiettivi di concezione molto originale in quanto la parte anteriore dell'apparecchio, una volta aperto, si separa dal dorso. Solo un apparecchio di altra marca, lo Zeca-flex, presenta una simile tecnica.

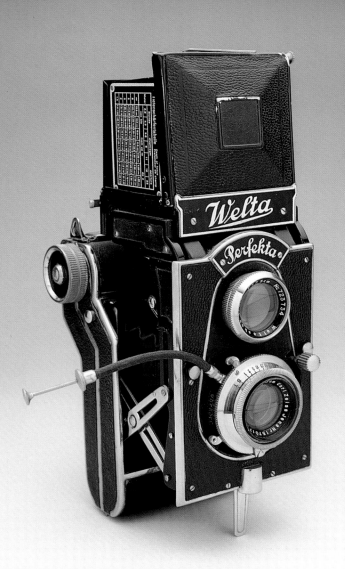

Ernemann "Ermanox"

1926 - GERMANY

This exceptional camera for 4.5 x 6 cm plates was made at the time when Ernemann merged with Zeiss. Its lens, extremely fast for the day with a f/1.8 aperture, made it possible for the first time to take photographs indoors or in weak light, with no need for a magnesium flash.

Ernemann "Ermanox" - 1926 - Germania

Questo apparecchio eccezionale per lastre di formato, 4,5 x 6 cm fu fabbricato al momento della fusione delle società Ernemann e Zeiss. Grazie al suo obiettivo ultra luminoso per l'epoca con apertura 1:1,8 fu per la prima volta possibile fotografare all'interno o con una luce debole, senza bisogno del flash al magnesio.

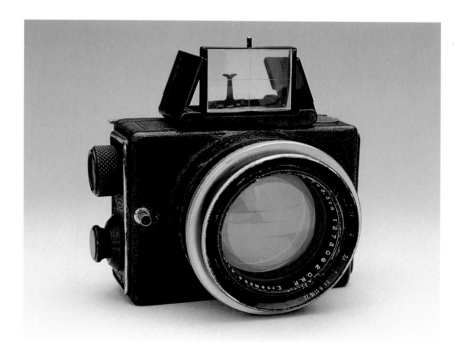

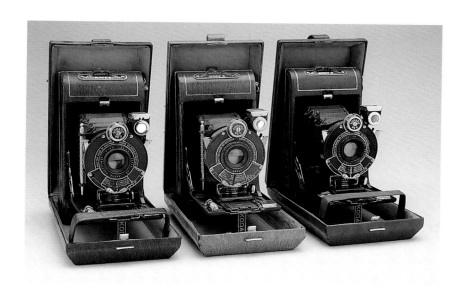

Kodak Vest Pocket "Vanity"

1926 - U.S.A.

*A*n elegant pocket model. Its "autograph" system allowed the photographer to etch inscriptions directly onto the film with a metal pencil, through an opening on the back of the camera.

Kodak Vest Pocket "Vanity" - 1926 - U.S.A

Un elegante modello tascabile. Una matita in metallo permetteva, attraverso il sistema "autografico," di imprimere le iscrizioni direttamente sulla pellicola, per mezzo di un'apertura posta sul dorso dell'apparecchio.

Voigtländer Prominent

1932 - GERMANY

A grand camera with an automatic release. It had a coupled rangefinder and a precise extending exposure meter. It could take photos in two formats: 6 x 9 or 4.5 x 6 cm.

Voigtländer Prominent - 1932 - Germania

Apparecchio di gran classe con apertura automatica. Era dotato di un telemetro accoppiato e di un preciso esposimetro ad estensione. Permetteva di fare riprese in due formati: 6 x 9 o 4,5 x 6 cm.

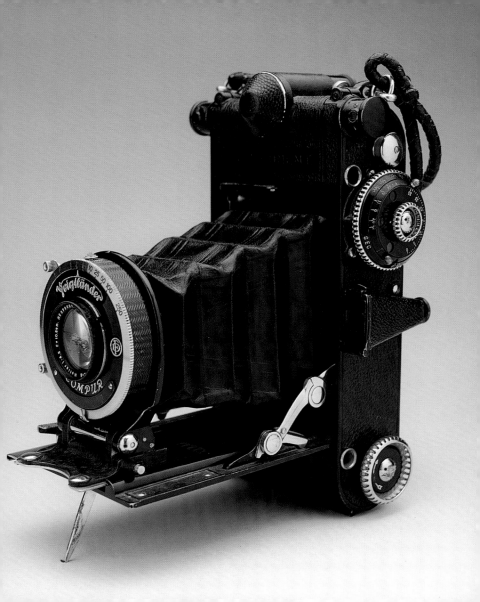

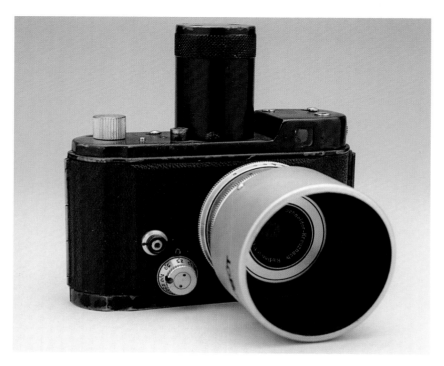

Robot (Otto Berning & Co.)

1934 - GERMANY

With its powerful spring motor, this camera could make a large number of exposures in a short time. During World War II, it was standard equipment on the Luftwaffe's fighter and reconnaissance planes.

Robot (Otto Berning & Co.) - 1934 - Germania

Questo apparecchio, grazie ad un potente motore a molla, permetteva di fare numerose riprese in breve tempo. Durante la guerra del 1940–45, costituiva parte dell' equipaggiamento degli aerei da caccia o da ricognizione della Luftwaffe.

Zeiss Ikon Contaflex

1935 - GERMANY

This esteemed twin-lens reflex camera in 24 x 36 mm format was the world's first to include a built-in photoelectric cell. It was the pinnacle of the camera-maker's art between the wars.

Zeiss Ikon Contaflex - 1935 - Germania

Questo prestigioso apparecchio reflex a due obiettivi per il formato 24 x 36 mm fu il primo al mondo a possedere una cellula fotoelettrica incorporata. Rappresentò il vertice nella tecnica di fabbricazione degli apparecchi fotografici fra le due guerre.

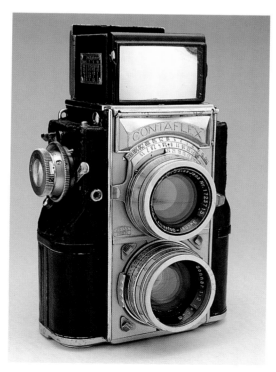

Zeiss Ikon Contax I

1932 - GERMANY

A high-quality compact camera. Its great advantages: a built-in rangefinder and interchangeable lenses.

Zeiss Ikon Contax I - 1932 - Germania

Un apparecchio compact di alta qualità. Suoi grandi vantaggi: telemetro incorporato e obiettivi intercambiabili.

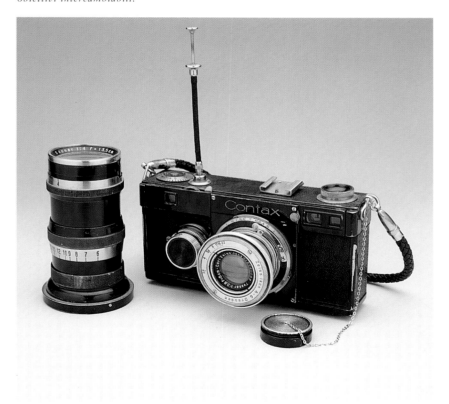

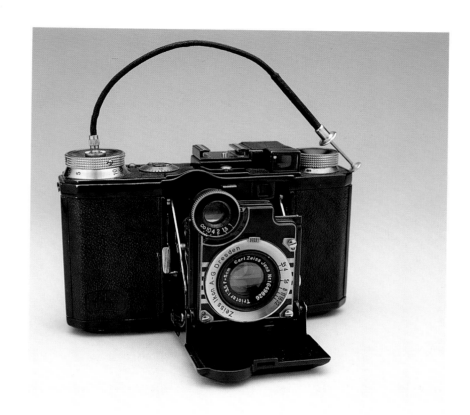

Zeiss Ikon Super Nettel

1935 - GERMANY

This esteemed compact camera in 24 x 36 mm format could compete with the best of the age, and it cost less than the Contax I in the same 35-mm format.

Zeiss Ikon Super Nettel - 1935 - Germania

Questo pregiato apparecchio compact di formato 24 x 36 mm poteva fare concorrenza alle migliori produzioni di quell'epoca e costava molto meno della Contax I dello stesso formato, 35 mm.

Zeiss Super Ikonta

1937 - GERMANY

One of the most attractive cameras of the pre-war era; 4.5 x 6 cm format and high-quality optical system. Many amateurs became enthusiastic photographers thanks to the excellent results they got with this camera, or its 6 x 9 cm big brother.

Zeiss Super Ikonta - 1937 - Germania

Uno dei più begli apparecchi dell'ante guerra, formato 4,5 x 6 cm, ottica di alta qualità. Numerosi amatori sono diventati fotografi entusiasti grazie agli eccellenti risultati ottenuti con questo apparecchio o con il suo fratello maggiore di formato 6 x 9 cm.

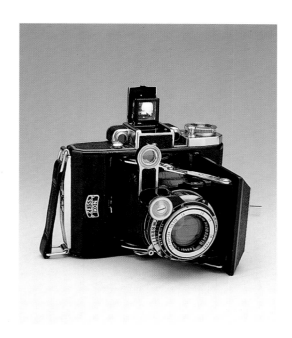

Jhagee Exa II A & Exacta Varex II A
1938 AND 1951 - GERMANY

Two single-lens reflex cameras of very similar quality—one from before World War II and the other from after.

Jhagee Exa II A & Exacta Varex II A - 1938 e 1951 - Germania
Due reflex mono-obiettivo di qualità molto simili tra loro, ma datati prima e dopo la Seconda Guerra Mondiale.

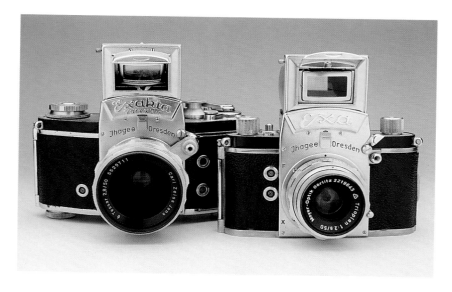

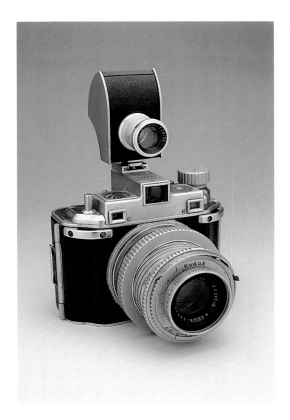

Kodak Medalist II

1 9 4 6 - U . S . A .

A highly evolved camera widely used by reporters and professional photographers of the day.

Kodak Medalist II - 1946 - U.S.A.

Apparecchio perfezionato largamente utilizzato all'epoca da reporters e fotografi professionisti.

Agfa Flexilette

This was the first twin-lens camera to be produced in Germany after World War II. It has an original and unusual design, and it uses 35 mm film (24 x 36).

Agfa Flexilette - 1960 - Germania

Questo apparecchio è il primo a due obiettivi prodotto in Germania dopo la guerra del 1940–45. La sua concezione è originale e inconsueta. Utilizza il formato 35 mm (24 x 36).

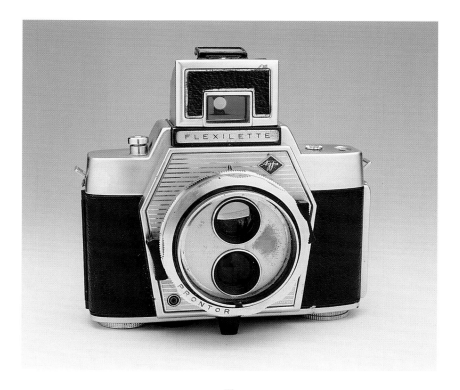

Zeiss Ikon Kolibri

1930 - GERMANY

This small, lightweight camera with impeccable detailing was a classic of the age and a great success—especially with women, who could easily carry it in a purse.

Zeiss Ikon Kolibri - 1930 - Germania

Questo apparecchio piccolo, leggero e dalle finiture impeccabili contrassegnò l'epoca e conobbe un grande successo specialmente presso le donne che potevano trasportarlo facilmente in borsa.

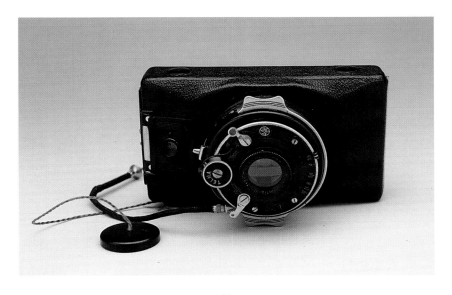

Special Kodaks

1 9 3 4 - U . S . A .

Cameras used solely to reproduce pictures in 6.5 x 11 cm format from 16 mm and 35 mm film.

Kodaks Speciali - 1934 - U.S.A.

Apparecchi utilizzati unicamente per la riproduzione in formato, 6,5 x 11 cm delle pellicole di 16 e 35 mm.

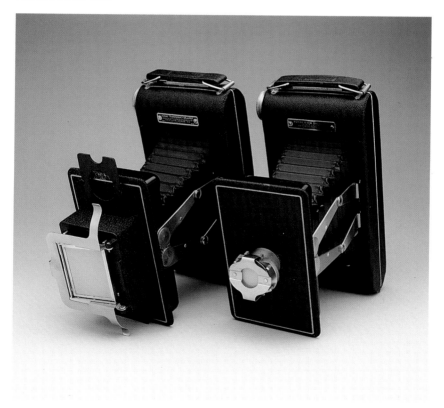

Graflex Photorecord
1 9 4 4 - U . S . A .

This unusual American camera could make 750 exposures in 24 x 36 mm format on movie film. It was used to take mug shots in prisons.

Graflex Photorecord - 1944 - U.S.A.

Questo originale apparecchio americano poteva fare 750 riprese su formato 24 x 36 mm su pellicola per cinema. Veniva utilizzato nelle prigioni per fare la scheda fotografica dei prigionieri.

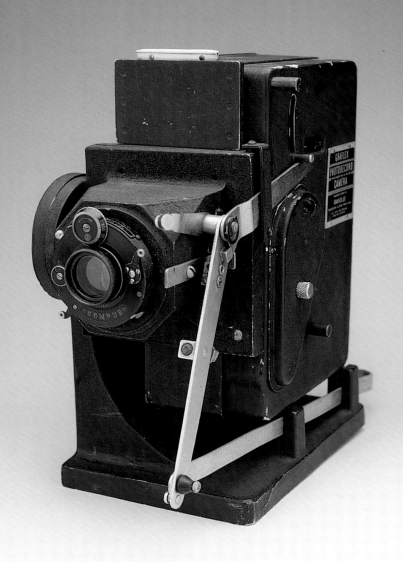

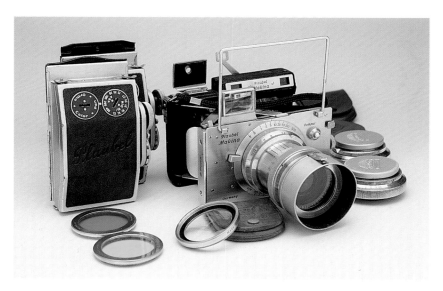

Plaubel Makina III D

1 9 4 9 - GERMANY

A camera in 6 x 9 cm format, used by many reporters and professional photographers. It came in a carrying case with about thirty high-quality accessories.

Plaubel Makina III D - 1949 - Germania

Macchina di formato 6 x 9 cm utilizzata da molti reporters e fotografi professionisti. Questo apparecchio è integrato in una valigia dotata di una trentina di accessori di alta qualità.

Kodak "Regent"

1935 - U.S.A. AND GERMANY

Conceived by Kodak and made in Germany, this beautiful automatic-release camera came with a coupled rangefinder, and could take pictures in two formats. It has a smooth, exceptionally streamlined surface when closed.

Kodak "Regent" - 1935 - U.S.A. e Germania

Ideato dalla Kodak e fabbricato in Germania, questo bellissimo apparecchio ad apertura automatica era dotato di un telemeto accoppiato e permetteva di fare riprese di due formati. Piegato, offre una superficie liscia e particolarmente aerodinamica.

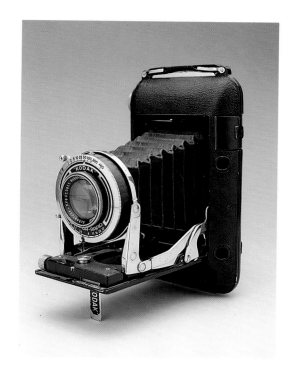

A.R.M. Ltd. Rajar No. 6

1924 - GREAT BRITAIN

Of simple mechanical construction, this camera is a fine example in Bakelite, a synthetic material that could be used for high-quality products. One of the first photographic applications of this manufacturing process.

A.R.M. Ltd. Rajar N° 6 - 1924 - Gran Bretagna

Semplice nella sua realizzazione meccanica, questo apparecchio è un bell'esempio di utilizzazione della Bakelite, materiale sintetico che permette applicazioni di alta qualità. Si tratta di una delle prime utilizzazioni di questo procedimento di fabbricazione.

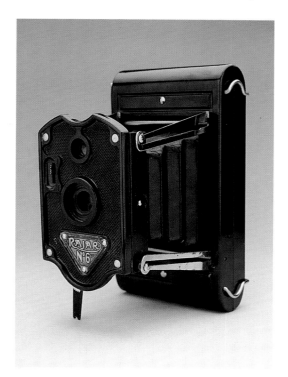

Houghton Ensign Midget
1934 - GREAT BRITAIN

This miniature camera, very painstakingly produced, used special English "Lukos" film and could make six 3.7 x 5.7 cm exposures.

Houghton Ensign Midget - 1934 - Gran Bretagna

Questo apparecchio in miniatura dalla fabbricazione assai curata utilizzava speciali pellicole inglesi "Lukos" e faceva 6 riprese di 3,7 x 5,7 cm.

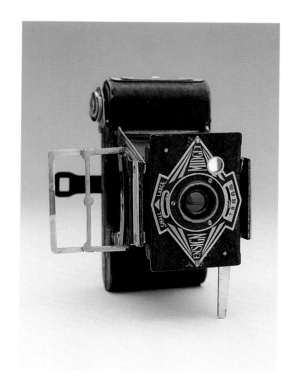

Maton

1930 - GREAT BRITAIN

This unique camera was made by the British company, Multipose Portable Cameras Ltd. It was fast, able to make twenty-four exposures in twelve seconds. A special rapid-development process yielded a finished photograph in under ten minutes.

Maton - 1930 - Gran Bretagna

Questo apparecchio molto originale era fabbricato dalla compagnia inglese "Multipose Portable Cameras Ltd." Permetteva di fotografare molto rapidamente al ritmo di 24 riprese in 12 secondi. Un procedimento di sviluppo particolare e rapido forniva una foto definitiva in meno di dieci minuti.

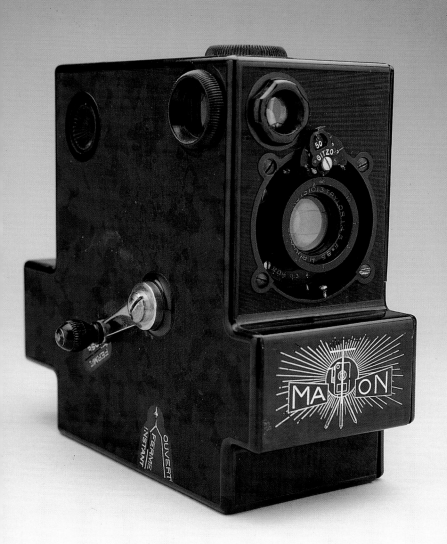

Univex Model AF-2
1 9 4 1 - U . S . A .

A miniature camera prettily adorned in late Art Deco style.

Univex Modello AF-2 - 1941 - U.S.A.
Apparecchio in miniatura con un grazioso decoro "art déco" tardivo.

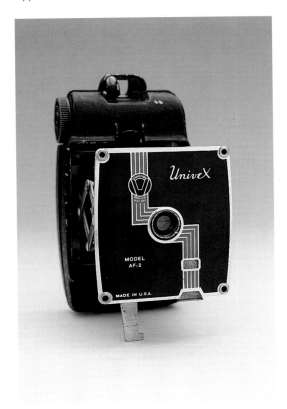

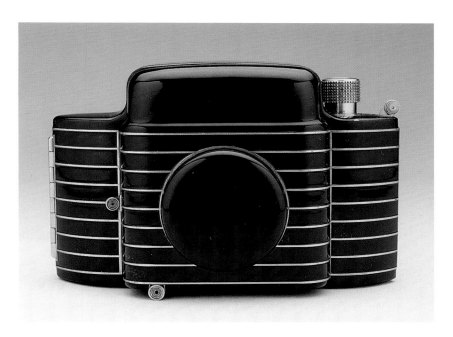

Kodak Bantam Special

1 9 3 6 - U . S . A .

With this 24 x 36 mm model designed by Walter Dorwin Teague, Kodak produced what is undoubtedly one of the most beautiful cameras of all time. Its extremely high technical quality yielded excellent results.

Kodak Bantam Special - 1936 - U.S.A.

Con questo modello di formato 24 x 36 mm, disegnato da Walter Dorwin Teague, la Kodak ha senza dubbio prodotto il più bell'apparecchio di tutti i tempi. La perfezione tecnica permetteva di ottenere eccellenti risultati.

Coffeemakers

Men's Hats

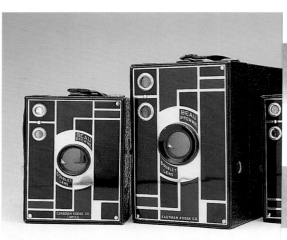

Fountain Pens

Kodak "Beau Brownie"

1 9 3 0 - U . S . A .

These box cameras, technically simple, became regular ma
the hands of Walter Dorwin Teague. They came in a variet
and since the lenses were good, took excellent photos.

Kodak "Beau Brownie" - 1930 - U.S.A.

*Queste macchine fotografiche a cassetta, tecnicamente sem
mate in veri e propri capolavori dell'art dèco da Walter D
Esistevano in più combinazioni di colori e, grazie ad obiet
realizzavano foto eccelenti.*

Perfume Bottles

CHRONICLE BOOKS

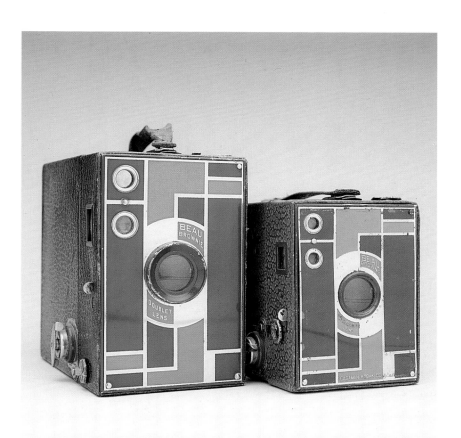

Kodak Baby Brownie and Kodak Baby Brownie Special

1934 AND 1936 - U.S.A.

Bakelite cameras, simple but very well made, with a design typical of the era. They fascinated an entire generation of young people.

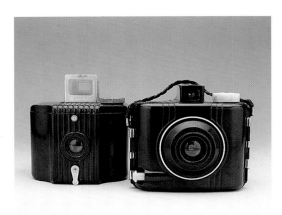

Kodak Baby Brownie & Kodak Baby Brownie Special - 1934/1936 - U.S.A.

Apparecchi in Bakelite, semplici ma molto ben costruiti; design tipico dell'epoca. Hanno affascinato un'intera generazione di giovani.

Kodak Six 16

1932 - U.S.A.

A camera made with immense care; it has outstanding mechanical quality and an automatic release. The outer casing is pure Art Deco.

Kodak Six 16 - 1932 - U.S.A.

Apparecchio fabbricato con immensa cura, dotato di una meccanica superba e di apertura automatica. Rivestimento nel più puro stile art dèco. ➤

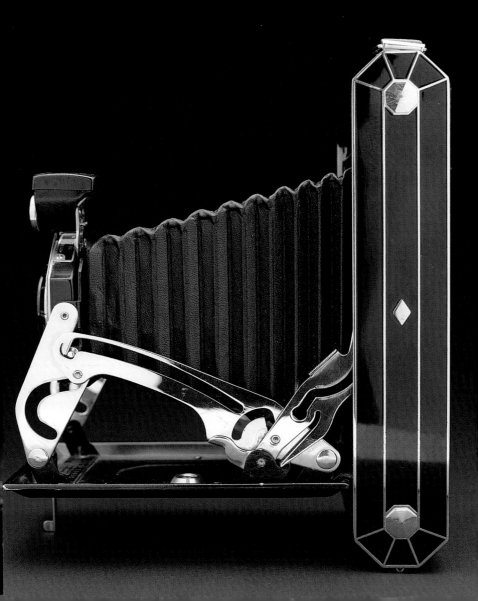

Polaroid Land Camera, Model 95

1944 - U.S.A.

This was the first model made by the famous company founded by Dr. Land. It signaled the beginning of a long and highly diversified product line that still dominates the world market in instant photography.

Polaroid Land Camera Modella 95 - 1944 - U.S.A.

Questo apparecchio fu il primo modello prodotto dalla celebre ditta creata dal Dr. Land. Segnò l'inizio di una lunga produzione molto diversificata e che tutt'oggi regna con lo stesso successo sul mercato mondiale della fotografia istantanea.

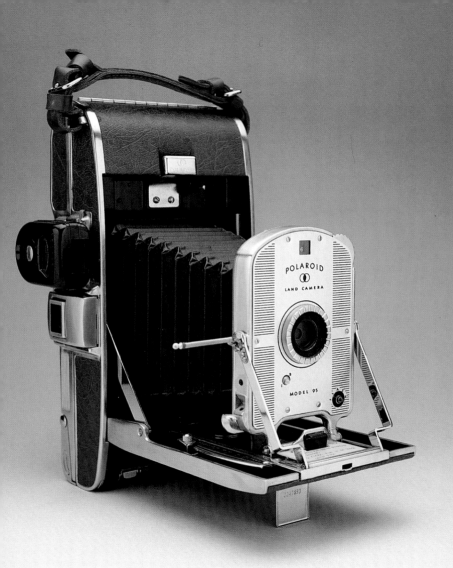

Leica "Luxus," gold and lizard skin

1930 - GERMANY

This top-of-the-line Leica is sometimes called the "Maharaja's Leica." Fewer than a hundred models were made from 1929 to 1931. In its original carrying case, this one includes not only the camera itself (numbered 49171) but also a rangefinder from the period, likewise gold-plated.

Leica "Luxus" oro e pelle di lucertola - 1930 - Germania

Si tratta di una "Leica" primo modello, talvolta chiamata "Leica per Maharajah" di cui furono costruiti meno di cento modelli fra il 1929 e il 1931. Questo modello contiene nel suo astruccio originale non solo l'apparecchio, che porta il numero 49171, ma anche un telemetro in uso all'epoca, anch'esso placcato in oro.

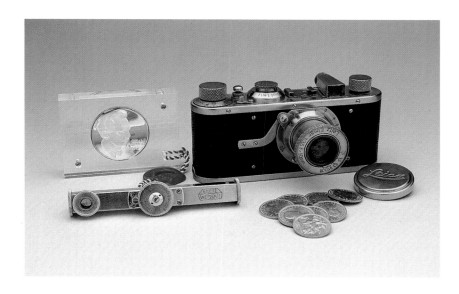

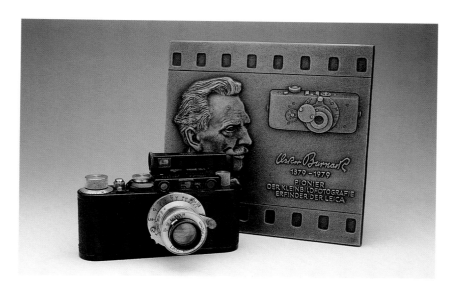

Leica II

1932 - GERMANY

This model was the first Leica to have a coupled rangefinder. Here it is outfitted with an angled viewfinder that let the user take photos unobtrusively by seeming to point the camera elsewhere. The plaque commemorates Oscar Barnack, hired by Ernst Leitz in 1911 on the advice of a colleague named Mechau. A brilliant engineer with a strong practical intuition, Barnack made Leitz's fortune by inventing the Leica.

Leica II - 1932 - Germania

Questo modello di Leica è il primo a possedere un telemetro accoppiato. E' qui equipaggiato di un mirino d'angolo con il quale si poteva fotografare discretamente fingendo di mirare altrove. La targa commemorativa è state realizzata in memoria del celeberrimo Oscar Barnack, il quale fu assunto da Ernst Leitz nel 1911 su consiglio del collega Mechau. Ingegnere brillante e dotato di spirito pratico, O. Barnack fece la fortuna di Leitz grazie alla Leica, di cui fu l'inventore.

Leica III A

*O*ne of the many improved versions of the Leica II, which had first been made in 1932. In 1938, the company produced 5,800 chrome-plated cameras. The viewfinder, with its multiple frames, was used with different lenses. The "Summar F 1:2" was an exceptionally fast lens for its day.

Leica III A - 1938 - Germania

Questo apparecchio è una delle numerose versioni migliorate delle Leica II, la cui produzione era iniziata nel 1932. Nel 1938 furono prodotti 5800 apparecchi in versione cromata. Il mirino a quadri multipli veniva utilizzato con diversi obiettivi. Il "summar F 1:2" era per l'epoca un'ottica eccezionalmente luminosa.

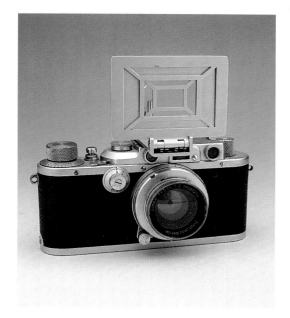

Leica III

1 9 3 3 - G E R M A N Y

*T*his compact and very high-quality carrying case contained a wide variety of lenses and accessories, including a 35 mm wide-angle lens, a rare 73 mm telephoto lens (Hektor), viewfinders, filters, and other items.

Leica III - 1933 - Germania

Questa valigia compatta e di pregiata qualità conteneva svariati obiettivi e accessori, fra cui un grandangolo di 35 mm, un raro teleobiettivo di 73 mm (Hektor), visori, filtri, e altri accessori. ➢

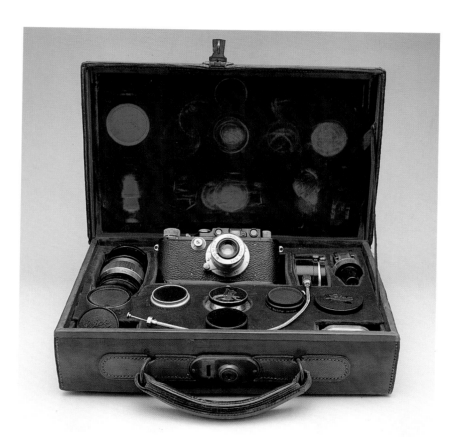

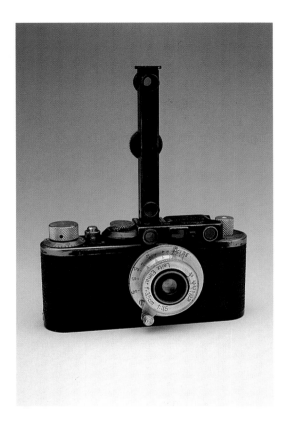

Leica II

**1 9 3 2 -
GERMANY**

This camera, numbered 71392, was one of the earliest in the Leica II line. It was used in the Far East for many years by a correspondent of a major English newspaper.

Leica II - 1932 - Germania

Questo apparecchio, che porta il n. 71392, fu uno dei primi modelli (di Leica II). Fu utilizzato per molto tempo in Estremo Oriente da un corrispondente di un grande giornale inglese.

Leica III A

1935 - GERMANY

The first Leica model fitted with a shutter that could reach a speed of 1/1000th of a second.

Leica III A - 1935 - Germania

Questo apparecchio è primo modello dotato di un otturatore che raggiunge la velocità di 1/1000 di secondo.

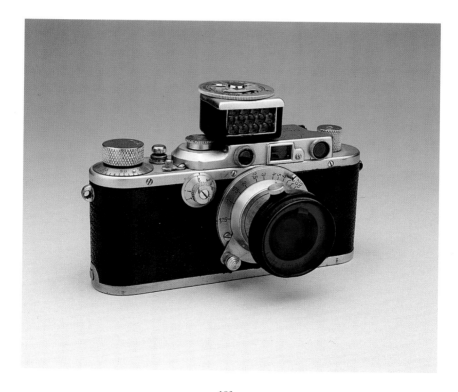

Leica III

1936 - GERMANY

A model fitted with the Summar 1:2 lens, the fastest that Leitz produced at the time.

Leica III - 1936 - Germania

Modello equipaggiato con l'obiettivo Leitz, più luminoso a quel tempo prodotto da questa ditta: il Summar 1:2.

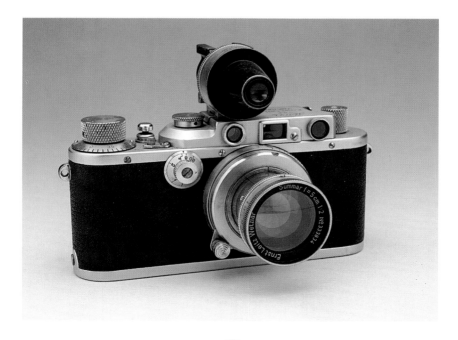

Leica R 4

Though it looks absolutely normal, both inside and out—the body can even be opened—this camera is actually a dummy, made by Leica for shop window displays as a serious discouragement for thieves.

Leica R 4 - 1980 - Germania

Questo apparecchio d'aspetto assolutamente normale, all'esterno come all'interno, il corpo macchina è infatti apribile, è in realtà un falso fabbricato della Leica per essere posto nelle vetrine dei negozi e in questo modo scoraggiare seriamente i ladri!

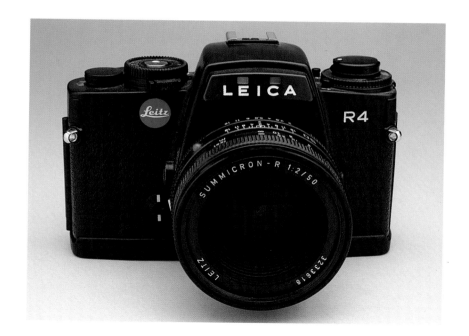

Canon III

This good-quality camera is a technological step forward from one of the many Leica copies made by this major Japanese manufacturer in the years before World War II.

Canon III - 1952 - Giappone

Questo apparecchio di buona qualità rappresenta una realizzazione tecnologicamente evoluta di una delle numerose copie della Leica prodotte dalla grande Casa giapponese negli anni precedenti la Seconda Guerra Mondiale.

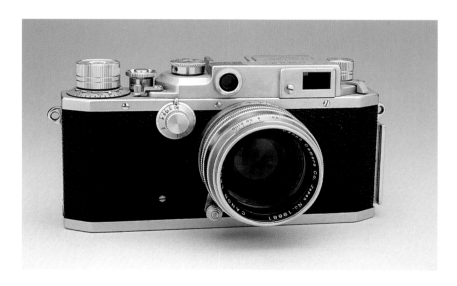

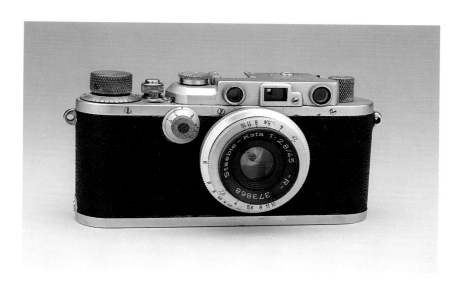

Nicca T 3

1 9 4 9 - J A P A N

*A*n almost exact copy of the Leica II.

Nicca T 3 - 1949 - Giappone
Si tratta qui di una copia quasi conforme alla Leica II.

Fed

1 9 4 7 - U . S . S . R .

A mechanically simplified copy of the Leica II.

Fed - 1947 - U.R.S.S.
Copia semplificata, dal punto di vista meccanico, del modello Leica II.

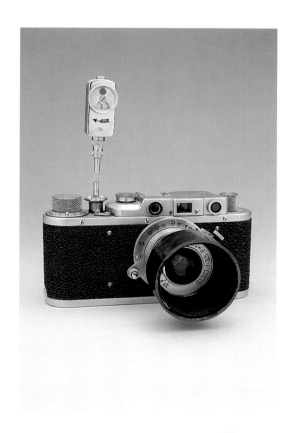

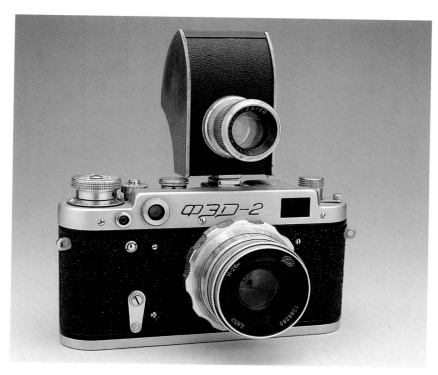

Fed 2

1 9 5 5 - U . S . S . R .

Though not an exact copy of a Leica, this camera was at least strongly inspired by
Leitz products. The body has a removable "flexameter" viewfinder made in Germany.

Fed 2 - 1955 - U.R.S.S.

*Questo apparecchio, pur non essendo una copia esatta della Leica, era per lo Meno
fortemente ispirato dalle produzioni di Leitz. Il corpo è equipaggiato di un mirino
reflex asportabile "flexameter," di fabbricazione tedesca.*

Gamma Perla A

CIRCA 1951 - ITALY

A well-made Italian camera inspired by pre-war Leicas. The German Steinheil lens, much sought after and very sensitive, was made in Munich; its lens speed is f/2.8.

Gamma Perla A - circa 1951 - Italia

Apparecchio italiano di pregiata fabbricazione ispirato alle Leica di prima della guerra. L'obiettivo tedesco Steinheil, pregiato e molto luminosa, fu fabbricato a Monaco. La sua apertura è di 1:2,8.

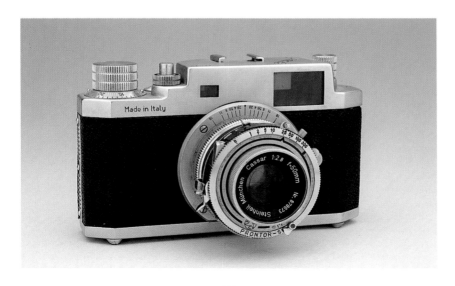

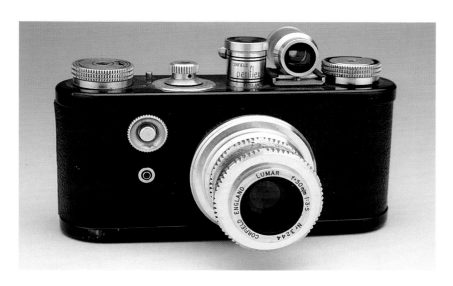

Corfield Periflex
1953 - GREAT BRITAIN

This very carefully manufactured camera was made in England to attract Leica fans. Leitz lenses could be mounted on this novel body, fitted with a periscope-type vertical reflex viewfinder and a glass film holder.

Corfield Periflex - 1953 - Gran Bretagna
Questo apparecchio molto curato fu prodotto in Inghilterra per sedurre gli affezionati amatori della Leica. Gli obiettivi Leitz potevano essere montati su questo corpor origi-nale dotato di un mirino verticale reflex del tipo a periscopio e di un pressapellicola in vetro.

Ducati Sogno

CIRCA 1950 - ITALY

This excellently made and beautifully detailed little camera could make fifteen 18 x 24 cm exposures on 35-mm film in special cartridges. The optical systems were interchangeable, and the body even had a coupled rangefinder.

Ducati Sogno - circa 1950 - Italia

Questo piccolo apparecchio di eccellente fabbricazione e finitura faceva 15 riprese di formato 18 x 24 su una pellicola di 35 mm in caricatori speciali. Le ottiche erano intercambiabili e il corpo comprendeva persino un telemetro accoppiato.

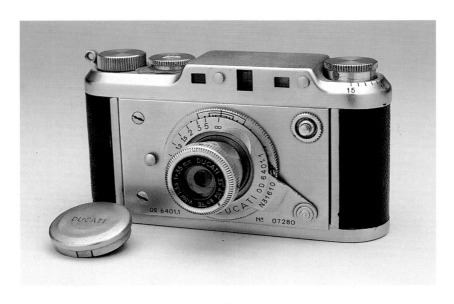

Mercury II
1 9 4 0 - U . S . A .

A sophisticated American camera from the Universal Camera Corporation of New York. It has curious and contradictory characteristics: It used special, wide 35 mm film to take vertical shots. The rotating shutter could reach 1/1000th of a second.

Mercury II - 1940 - U.S.A.

Sofisticato apparecchio americano, fabbricato dalla Universal Camera Corporation di New York, presentava caratteristiche curiose e contraddittorie. Utilizzava una larga pellicola speciale di 35 mm per fare riprese in verticale. L'otturatore rotavio raggiungeva la velocità di 1/1000 di secondo.

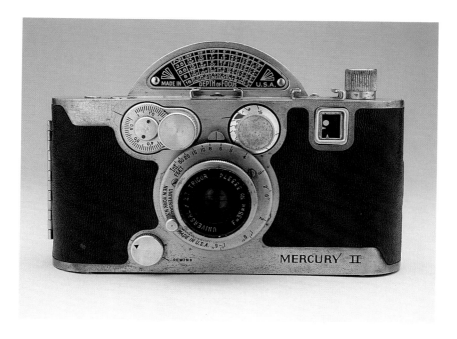

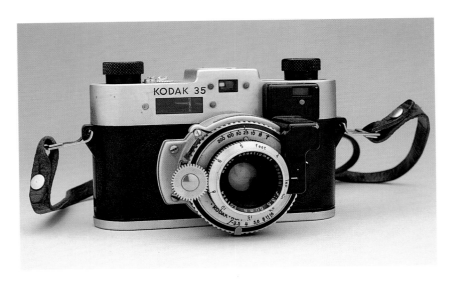

Kodak 35

1 9 4 0 - U . S . A .

The rather unsophisticated look was dictated by market necessities: The camera was designed to be sold for the reasonable price of between $15 and $34. The Kodak 35, with its own rangefinder, used a brand-new type of film: 35 mm on disposable 135 spools—the same as we use today.

Kodak 35 - 1940 - U.S.A.

L'apparenza piuttosto rustica della costruzione è dettata da esigenze di mercato: l'apparecchio era stato infatti concepito per poter essere venduto ad un prezzo ragionevole fra 15–34$. La Kodak 35 munita di telemetro utilizzava le pellicole, allora nuovissime, di 35 mm in bobine di 135 gettabili; le stesse oggi utilizzate.

Le Franceville

The Franceville was a basic camera; the shutter simply works by gravity. Size: 6.7 x 4.7 cm.

Le Franceville - 1908 - Francia

Il Franceville è un apparecchio base: l'otturatore funziona solamente per gravità. Dimensioni: 6,7 x 4,7 cm.

The Kombi

1 8 9 3 - U . S . A .

The Kombi was better made, and could be used as either a camera or a viewer. Size: 5.2 x 4.2 cm.

The Kombi - 1893 - U.S.A.

La fabbricazione del Kombi è più curata ed esso poteva servire sia come apparecchio fotografico sia come visore. Dimensioni: 5,2 x 4,2 cm.

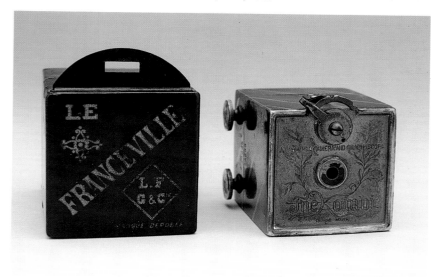

Expo Watch, Houghton Ticka, Magic Photoret

1 9 0 4 , 1 9 0 6 , 1 8 9 4

Three miniature cameras, well attuned to their era's
fashion trends and very similar in inspiration.

Expo Watch - 1904
Houghton Ticka - 1906
Magic Photoret - 1894
*Tre realizzazioni in miniatura molto simili nella loro
ispirazione e rispondenti alla moda del tempo.*

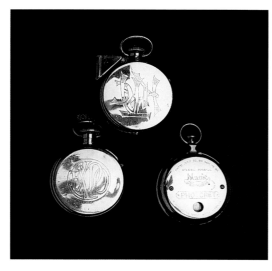

Coronet Midgets

**1 9 3 5 - G R E A T
B R I T A I N**

These miniature cameras, with
their highly original design,
were made of Bakelite. They
could take six shots on special
film; the lens was a Taylor
Hubson meniscus with an f/10
aperture. The shutter had a
speed of 1/30th of a second.

**Coronet Midgets - 1935 -
Gran Bretagna**
*Questi apparecchi in miniatura
di concezione molto originale
erano costruiti in Bakelite.
Facevano 6 riprese su una spe-
ciale pellicola; l'obiettivo era un
menisco Taylor Hubson di aper-
tura f/1:10; l'otturatore fun-
zionava ad una velocità di 1/30
di secondo.* ➤

Coronet "Vogue"

1936 -
GREAT BRITAIN

A highly prized miniature
Bakelite camera. It used spe-
cial film made in England by
the manufacturer.

Coronet "Vogue" - 1936 -
Gran Bretagna

*Pregiato apparecchio in
miniatura in Bakelite; utiliz-
zava una speciale pellicola
fabbricata dal costruttore
in Inghilterra.*

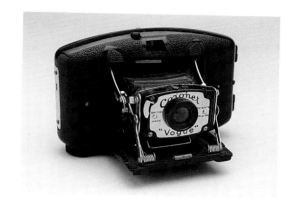

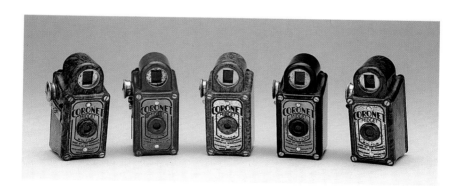

Minox

High-quality miniature cameras for espionage, made in Riga before World War II and in Germany ever since.

Minox - circa 1950, 1960 e 1970 - Germania

Prestigiosi apparecchi in miniatura per spionaggio realizzati prima della guerra del 40–50 a Riga, poi sino ai nostri giorni in Germania.

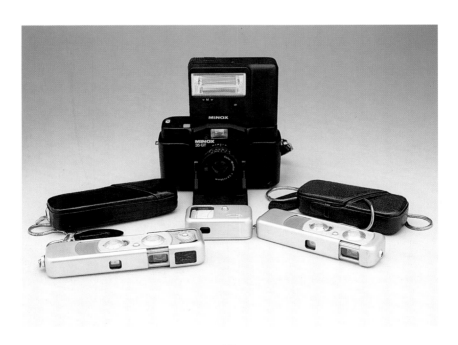

Goertz Minicord III
1958 - AUSTRIA

𝒯his miniature camera is the smallest twin-lens reflex camera ever made. It made forty 10 x 10 mm exposures on 16 mm film in special cartridges.

Goertz Minicord III - 1958 - Austria

Questo apparecchio in miniatura è più piccola reflex a due obiettivi mai costruita. Faceva 40 riprese di 10 x 10 mm su una pellicola di 16 mm, in speciali caricatori.

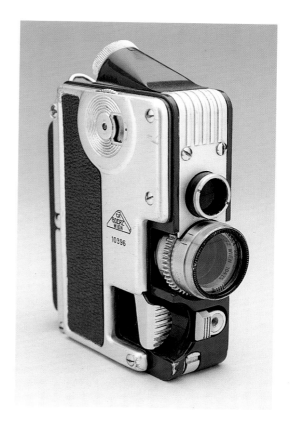

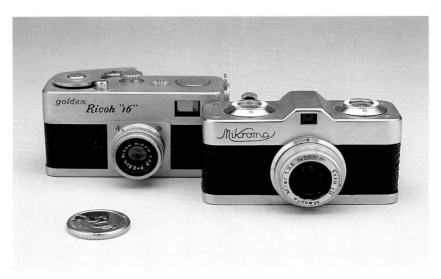

Golden Ricoh "16"
1952 - JAPAN

Mikroma (Meopta)
1949 - CZECHOSLOVAKIA

𝒯wo outstandingly well-made cameras with very similar, small dimensions: 35 x 75 mm versus 28 x 75 mm. The excellent lenses took very good photos on 16-mm film.

Golden Ricoh "16" - 1952 - Giappone
Mikroma (Meopta) - 1949 - C.S.
Due apparecchi di egregia fabbricazione e di dimensioni simili molto ridotte: 35 x 75 mm; 28 x 75 mm. Gli eccellenti obiettivi permettevano di fare foto di buona qualità su pellicole di 16 mm.

Sakura Seiki Co. "Petal"

1948 - JAPAN

*T*hese tiny cameras were only about 30 mm in diameter and weighed about 50 grams. Sturdy and well made, they are said to have been used sometimes by geishas to take compromising (and undoubtedly profitable) photographs.

Sakura Seiki Co. "Petal" - 1948 - Giappone

Questi minuscoli apparecchi misuravano circa 30 mm di diametro e pesavano suppergiù 50 gr. Robusti e ben costruiti, si diceva che fossero talvolta utilizzati dalle geishe per fare riprese compromenttenti . . . e certo ben remunerate.

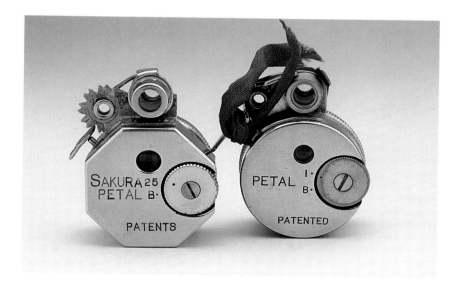

R. Steineck A.B.C.

This model's maker claimed it was the smallest precision camera in the world. In wristwatch format, it makes six 3 x 4 mm exposures on a special round film, 25 mm in diameter. It could be focused by looking either through the camera body itself (in which case the watch had to be taken off) or through an ingenious "semi-reflex" viewfinder system.

R. Steineck A.B.C. - 1950 - Germania e Svizzera

Fu lo stesso costruttore ad annunciare che si trattava del più piccolo apparecchio fotografico di precisione al mondo! A forma di orologio da polso, faceva 6 riprese di 3 x 4 mm su una speciale pellicola rotonda del diametro di 25 mm. Era possibile inquadrare sia attraverso il corpo della macchina (era necessario allora togliere l'orologio dal polso) sia attraverso un'ingegnoso sistema "semi-reflex."

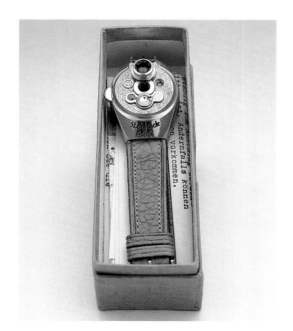

Camera Lite

1950 - U.S.A. AND JAPAN

A spy camera the size and shape of a Zippo lighter—and the lighter works. The photographic mechanism itself, with its 16-mm film cartridges, weighs only 20 grams.

Camera Lite - 1950 - U.S.A. e Giappone

Apparecchio per spionaggio della grandezza e della foggia di un accendino di tipo "zippo," quest'ultimo peraltro normalmente funzionante. La parte fotografica, con i suoi caricatori di pellicole 16 mm, pesa solamente 20 gr.

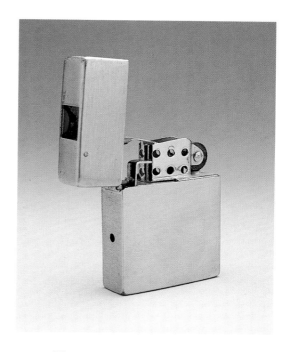

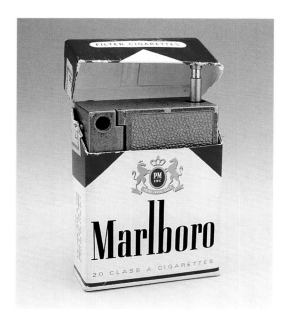

Whittaker Micro 16
1 9 5 0 - U . S . A .

Carefully but simply designed, this camera could make twenty-four rapid exposures in 14 x 14 mm format on 16-mm film in a special cartridge. A true spy's instrument, it fits perfectly into a pack of cigarettes.

Whittaker Micro 16 - 1950 - U.S.A.

Questo apparecchio, dalla costruzione accurate ma semplice, permetteva di fare 24 rapide riprese di 14 x 14 mm su una pellicola di 16 mm in uno speciale caricatore. Può essere considerato come un vero e proprio apparecchio per spionaggio in quanto può entrare e nascondersi perfettamente in un pacchetto di sigarette.

Tessina II (Convava S.A.)

1960 - SWITZERLAND

Despite its small format, this extremely high-precision miniature camera used 35-mm film. A spring motor gave it a capacity for six or seven very quick exposures. A removable strap allowed it to be used on the wrist.

Tessina II (Convava S.A.) - 1960 - Svizzera

Questo apparecchio in miniatura di altissima precisione utilizzava, nonostante il suo piccolo formato, una pellicola di 35 mm. Un motore a molla permetteva di fare molto rapidamente circa 6 o 7 riprese. Poteva essere utilizzato sul polso grazie ad un cinturino amovibile.

Compass I (Le Coultre)

1937-1950 - SWITZERLAND

This noteworthy instrument could use either 35-mm film in a special cartridge or flat film. In technical and aesthetic details it outdid other cameras of its age, particularly those in miniature format.

Compass I (Le Coultre) - 1937 - 1950 - Svizzera

Questo notevole apparecchio utilizzava sia pellicole di 35 mm su caricatori speciali, sia pellicole piane. Era dotato di finiture e perfezionamenti tecnici di livello superiore rispetto agli altri apparecchi dell'epoca, soprattutto nella categoria degli apparecchi in miniatura.

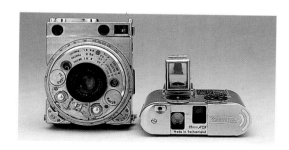

An Assortment of Miniature Cameras

CIRCA 1950-1960

𝐼n good light all these tiny, lightweight (24 to 40 grams) cameras could take acceptable photographs. Nevertheless, some are no more than attractive, amusing toys.

Svariati apparecchi in miniatura - circa 1950–60

Il buone condizioni di luce, tutti questi apparecchi minuscoli e leggeri (da 24 a 40 gr) potevano eseguire fotografie di qualità accettabile. Alcuni di lori sono tuttavia semplici divertenti, simpatici gingilli.

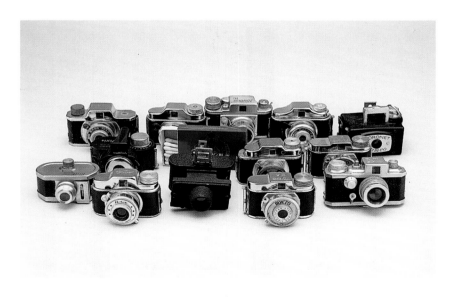

Mick-a-Matic, Mickey Camera, Bugs Bunny
1 9 6 0 - 1 9 7 0

Children's cameras made in the U.S. or Hong Kong. Walt Disney's films have inspired many creations, particularly outside the United States. The same thing has happened to certain other well-known American products—there are cameras shaped like Coca-Cola cans, for example. These imaginative ephemera are undoubtedly worth collecting.

Mick-A-Matic, Mickey Camera, Bugs Bunny - 1960 - 1970
Apparecchi destinati ai bambini; fabbricati negli U.S.A. o ad Hong Kong. Le produzioni di Walt Disney hanno ispirato molte creazioni, soprattutto fuori dagli Stati Uniti. Lo stesso accade per certe grandi marche americane: vi sono ad esempio apparecchi fotografici a forma di Coca-Cola e così via. Effimere creazioni della fantasia, meritano senza dubbio di essere collezionati.

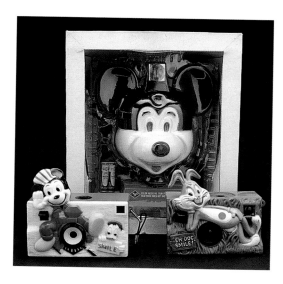

A Bit of History

THE FIRST CLICK

The first click—well, in fact there never was one. Today, we need only a quick, firm movement to take a photograph. How unlike the first photographers: The theatrical gesture with which they removed the cap from the lens bore an unmistakable resemblance to the motions by which people showed respect when addressing a person of distinction.

Indeed, this gesture almost made it seem as though the photographer were saluting nature or the sitter, whose image he was preparing to steal. It was the same movement as when gentlemen of the age ceremoniously doffed their hats when they met on the street. A broad, slightly solemn gesture, accompanied by a sweep of the elbow reminiscent of the "sweep" of the knee that eighteenth-century dancing masters taught in their schools of deportment.

But that gesture could not capture the moment as we can today, with cameras so sophisticated that a mere touch of the finger

can freeze an event in a fraction of the blinking of an eye. And so the results were risky, if not indeed unpredictable: Despite the patience required by interminable posing times, the outcome of the work remained uncertain even for the most talented photographer.

The first photographers had to be not only mechanics, opticians, and cabinetmakers but above all chemists. If users of the old "camera obscura" had had the chemical means to fix on some kind of surface the images they could already reproduce with their strange boxes and tents, photography might have been born and evolved centuries earlier—though in a more rudimentary form. Extant examples of the camera obscura that go back to the seventeenth century can in fact be considered true cameras, extraordinarily similar to our reflex models. Nothing is missing: from the lens to the objective to the mirror that reflects the image onto a ground glass. Their shapes and characteristics are directly evocative of some of the box cameras still in use today.

Yet long before these portable "cameras" were built, in the Near or Middle East of the far-off eleventh century, where eminent poets, astronomers, philosophers, and mathematicians flourished, exquisite tents were used to make camera obscuras whose only purpose was to divert their creators and their guests with projections of moving shadow theater.

Much later, toward the close of the fifteenth century, Leonardo da Vinci studied the principle of the camera obscura, which was then used only occasionally. He described the phenomenon completely and in minute detail in the *Codex Atlanticus*.

In a work called *Magia Naturalis* of 1558, Giovanni Battista della Porta reported that a convex glass lens could confer exceptional brightness and clarity on the image projected in a camera obscura. And though nobody had accused Leonardo da Vinci of sorcery, that was exactly the fate that befell Della Porta: A Church tribunal prosecuted him after he had given friends—one of whom no doubt was something of a blabbermouth—a camera obscura show that to them seemed like magic tinged with the work of the devil. Luckily he escaped, and after a prudent period in exile was able to tiptoe home.

The natural evolution of knowledge soon made it possible to find practical applications for the physical principles in question, and from the seventeenth century onward many artists began taking regular advantage of the possibilities offered by this ancient invention. The image, produced with or without a lens, was projected by natural light alone onto a glass plate. Covering the plate with a thin, translucent sheet of paper, and using a pencil or stick of charcoal, the artist could reproduce any image with absolute fidelity, in full and accurate perspective. Some of these camera obscuras were large enough for the artist to sit inside and work. Others could fold up, and were small enough to be easily portable.

The models built at the end of the eighteenth century, particularly by such specialists as Berger, had a variable-focus optical system, a real "zoom lens" before the fact, that allowed the user to frame and focus a perfect image on a ground glass. A simple shutter system, consisting of a series of masks, made the instrument beautifully adjustable

to the brightness of the daylight. And so we are confronted with an actual camera *avant la lettre*. If the user had had a photosensitive sheet of paper or glass plate, he could certainly have recorded the image, and would have had no further use for his pencil. Which was in fact exactly what happened, about a hundred years later, when the famous French photographer Eugène Atget tirelessly hauled his huge lenses in a brass container through the streets of Paris, afterward selling his precious documents to the great painters of the day to make their studio labors easier.

But it was not until the mid-nineteenth century, after more than a hundred years of stagnancy, that the situation finally regained momentum, thanks to the consecutive and sometimes combined efforts of inventors endowed with both ingenuity and curiosity. And yet none of them would likely have imagined what an extraordinary future was in store for the product of their endeavors. Both Charles in France and Wedgwood in England found ways to produce a transient image on a sensitive surface, but probably neither one imagined the great developments their discoveries would undergo with the definitive inventions of Joseph Nicéphore Niepce, Louis Daguerre, and Henry Fox Talbot. The influence of these latter three on modern history is immense, though often little known; it is no great exaggeration to say that they profoundly changed our everyday life. The ability first to record, and later reproduce, the excellent images already produced by the camera obscura would ultimately become the decisive factor in the evolution of modern photography and the photographic industry.

The Frenchman Niepce seems to hold the uncontested laurels for the initial discovery that would lay the foundations for future developments. Able, self-taught, and exceptionally determined, and after years of fruitless attempts and incessant research, Niepce finally achieved successful results in the years between 1815 and 1822. In 1827, while staying in London to visit his gravely ill brother, he expected to present a paper and possibly even an exhibit to the Royal Society. In his paper, he clearly established that he had developed an effective process that allowed him to record an image—not very precise but stable—on a support of bitumen from Palestine. It is odd to note that when Niepce was living at Chalon-sur-Saône, he used raw materials from the Dead Sea, even though there were bituminous schists not far from his then home. The reason for his choice has never been explained.

The disappointments and difficulties that Niepce suffered forced him, in 1829, to join forces with the painter and decorator Louis Daguerre, who like Niepce was researching a process that would allow him to obtain a truly fixed image. For some time Daguerre himself had been trying to negotiate a partnership with Niepce. Once the agreement was finally struck, however, Niepce died (in 1833) before he could enjoy its results.

Daguerre continued his experiments in concert with Isidore Niepce, Nicéphore's son. This research eventually yielded satisfactory results in 1837, or fifteen years after 1822, the date generally considered the birth of photography. And it was precisely these results that

Daguerre presented in 1839 to the Academy of Sciences in Paris, thanks to the interest and support of the celebrated physicist François Arago.

The success was immense and signaled the introduction of the first truly effective photographic process: daguerreotype. In a partnership with his brother-in-law Alphonse Giroux in Paris, Daguerre soon began building cameras that would quickly become at least as famous as their maker. Some of these cameras still exist, and are objects of unequivocal admiration and insatiable jealousy for any camera collector. They are of course priceless, and all are held by a very few museums, but there's no law against dreaming of some legendary barn where sits some precious wooden trunk, forgotten by everyone, containing a camera or lens by Alphonse Giroux and all the complicated and fascinating kit required for a daguerreotype.

And undoubtedly a connoisseur would also crave one of those little cubelike boxes, barely equipped with a lens and certainly not prepossessing in appearance, built in England by Henry Fox Talbot around 1835. In a sense it was these cameras, so simple they were nicknamed "mousetraps," that really ushered in modern photography. For Fox Talbot used them to take pictures on sensitized paper that acted as a negative, from which he could then produce an endless number of positive images.

It would take another century and a half, until around 1990, to create the first really practical examples of images that abandoned a chemical support for some other form—magnetic or electric. After Niepce, Daguerre, and Fox Talbot, photography continued to grow

with incredible speed, employing a variety of supports—metal or glass plates, sensitized papers or films—which in turn used silver nitrate, silver chloride, or silver iodide to fix and reproduce images. And in fact we are still living in the "silver age."

In the fifty years that followed, human imagination exerted itself to the fullest, and strange as it may seem, by the end of the nineteenth century virtually every type of camera produced by today's camera industry had already been conceived and manufactured. Although electronics make pictures easier to take, a modern reflex camera nevertheless works by exactly the same principles as were used by the first camera makers. And while from an aesthetic viewpoint true camera fans may certainly be excited by the technical perfection of a medium-sized modern camera or the futuristic design of an entirely automated compact, they will still retain a certain nostalgia for the precious woods, shining brass, fine leather, and bright nickel of earlier models. And imagine the aficionado's amazement at certain Art Deco–inspired masterpieces made by almost all the major producers some sixty years ago!

The first daguerreotype cameras had only fixed optical systems; focusing was performed on a ground glass using the relative movement between the two rigid boxes that formed the body of the camera. Almost immediately, late in 1839, Baron Séguier invented the bellows. Still in use today, it continues to be preferred for both the most sophisticated professional studio cameras and for much smaller but still excellent cameras such as the Minox 35. Séguier also conceived a cam-

era that could be disassembled to cope with one of the worst drawbacks encountered by enthusiasts of the new art form: The weight of the cameras interfered with mobility. His camera weighed no more than twenty kilograms, including the portable camera obscura—certainly an important development for its day, when a camera normally weighed fifty kilograms or more.

To digress briefly on size: Consider the largest camera in the world, built by Rolls Royce at Derby for an English printing house: It weighs over 30 tons and measures 14 meters long, 2.5 meters wide, and 2.7 meters high. At the other extreme we find the Minox EC, which measures only 8 x 3 x 1.5 cm, and weighs no more than 50 grams. Only a few years ago you could buy a Sakura Petal measuring 2.9 cm in diameter and weighing a bit less than 50 grams. But the record for light weight in a camera able to take real, individually framed pictures on 16-mm film still belongs to the Pixie, built by Whittaker in the U.S. It weighs only 20 grams, measured on a postal scale!

Back to the age of Séguier: Wooden cameras began to appear almost at once, involving amazing and elaborate contraptions. Examples include those of Charles Chevalier, Francis Fowkes, and the Parisian optician Hermagis. The latter camera, folded up, was only 4 cm thick. From then on, the whole world became a theater on which lenses were trained by an ever-growing number of amateurs and specialists, avid for unusual and ingenious images.

Improvements of the sensitive surface were varied, rapid, and significant. In less than half a century, Daguerre's plates, each so

complicated to use, were superseded by Fox Talbot's papers. The wet collodion soaking the sensitive plates was abandoned in favor of dry surfaces first, and then within a very short time, flexible films quite similar to those still used today. Cameras were already commonly using rolls of treated paper well before the turn of the century. The next step was to use celluloid as a support for the sensitive surface; though certainly more flexible and stronger, this material had the drawback of being highly flammable.

As for lenses and shutters, other components that are obviously essential to cameras, they too enjoyed a rapid and rather profound evolution from the second third of the nineteenth century onward. In 1839 "instant" photography was no doubt inconceivable; if you wanted to shoot a photo in full sunlight, the necessary exposure was half an hour. Though the resulting image was surprisingly sharp, this process could only be used for static subjects such as landscapes, still lifes, or monuments. Yet only a year later, an exceptionally fast lens was created through the ingenious cooperation of Voigtländer and Joseph Max Petzval, a professor of mathematics at the University of Vienna, who had been started on his research by the enthusiasm of a compatriot who had attended Daguerre's famous presentation at the Academy of Sciences.

Theirs was a surprising step forward: The exposure time was cut to less than a minute. Naturally, a portrait was possible only if the subject remained almost absolutely immobile. Thus began the era of armchairs equipped with a vast range of supports: for the elbows, the

neck, the back, even the knees. The immobility that was required for purely functional reasons at the same time gave the subject a dignified and composed air, an almost regal self-possession, which the customer obviously found quite satisfactory. Within a few years, before the end of the century, emulsions had become so sensitive that cameras were able to take series of exposures in rapid succession. Among them was Marey's "gun" camera, able to take more than twelve frames a second thanks to its amazingly fast shutter.

Shutters themselves underwent the same kind of evolution. Here, as in everything that concerns photography, human inventiveness was astonishing. In 1866, the German photographer Ottomar Anschütz produced an exceptional photograph of a cannon shot in one millionth of a second! A few years later, thanks to curtain shutters, and provided the light would allow, anyone could shoot a photograph in a fraction of a millionth of a second. In 1898, the French sculptor Jean Sigriste produced a revolutionary camera in binocular form, equipped with an excellent shutter whose speed ranged from 1/40th to 1/10,000th of a second.

Over the course of these auspicious years in the history of the camera, prior to World War I, production of cameras of every type grew so much that in 1913, one large German maker offered photography enthusiasts well over 150 different models with more than a thousand variants.

Sensitive plates were still widely used, although modern film was very much on the rise, thanks primarily to George Eastman and

his famous Kodak brand, which would win a position of great eminence in the world market. It seems that Eastman chose the name "Kodak" because it was so easy to pronounce in any language. Some contend that the brand had a less utilitarian and more sentimental origin: "Kodak" was supposedly the name of an African village that Eastman used as a base of operations for one of his countless filming expeditions.

In 1888 George Eastman put his first simplified Kodak on the market. The famous little black box was equipped with film that could take one hundred round photos, 65 mm in diameter. Once the film was full, the photographer would mail the camera to the factory, which would send it back after developing and printing the pictures. For the first time, the amateur only had to aim and shoot. This was a real revolution and an immense success.

Well before the end of the past century, giant and miniature cameras had been invented and refined, as well as single-rail cameras for studios, binocular cameras, single- and twin-lens reflex cameras, stereoscopic, panoramic, and even folding cameras.

We cannot forget to mention the invention of color, and of cameras able to develop their plates almost by themselves. For color photography, in 1874 the French physicist Ducos du Hauron patented a color camera that worked with a three-color process. Such an instrument had been developed by Maxwell in 1861, and some time still passed before the camera was put into production.

What shall we say about aerial photography? Even before 1900, Nadar and Badut had shot photographs from the air, one from a balloon and the other from a kite. In 1906, in Germany, powerful rockets some ten meters long were launched, equipped with nose-cone cameras. Not even carrier pigeons escaped this experimentation; the ingenious Dr. Julius Neubronner attached an ultralight panoramic camera to their crops.

For the rest, we must admit that although at first sight there is "nothing new under the sun" and the same basic principles continue to be used, in actuality it is only by the continuous practical application of these same essential principles that we have been able to achieve immense progress. The use and application of electronics will undoubtedly reveal fascinating prospects for the future of photography.

Since their beginnings, cameras have been produced in such a vast range of types that they represent an almost unlimited field of interest for the collector. Faced with such variety, one is almost forced to make a choice. So some aficionados limit themselves to a single well-defined category of cameras or a specific historical period. Others concentrate their efforts on one brand or country. Still others are interested only in wooden cameras, or miniature models. Certainly the field does not suffer a lack of options!

Surrendering to an enthusiasm that goes back to his childhood, the author of these lines has preferred to concentrate on anything that seems fascinating or exceptional, curious or unusual, in either aesthetic

or technical terms. The variety and beauty of cameras make it difficult and painful to renounce any type a priori. The author wishes happy hunting to all those who have had the patience to bear with him thus far and feel the urge to become collectors.

Bella Cosa